GOLDEN HURRICANE
FOOTBALL
at The University of Tulsa

GOLDEN HURRICANE FOOTBALL
at *The University of Tulsa*

Chad Bonham

ARCADIA

Copyright © 2004 by Chad Bonham.
ISBN 0-7385-3274-6

Published by Arcadia Publishing,
Charleston SC, Chicago IL, Portsmouth NH, San Francisco CA

Printed in Great Britain.

Library of Congress Catalog Card Number: 2004106224

For all general information contact Arcadia Publishing at:
Telephone 843-853-2070
Fax 843-853-0044
E-Mail sales@arcadiapublishing.com

For customer service and orders:
Toll-Free 1-888-313-2665

Visit us on the internet at http://www.arcadiapublishing.com

CONTENTS

ACKNOWLEDGMENTS

This book could not have happened without the cooperation of The University of Tulsa athletic department. In particular, I would like to thank Judy MacLeod, Don Tomkalski, Jason West, Stephanie Hall, and Roger Dunaway for their invaluable support and assistance.

I must also thank those who allowed me to interview them for the project. They are Wes Caswell, John Cooper, Steve Gage, Jenk Jones, James Kilian, Steve Kragthorpe, Ken MacLeod, David Rader, Jimmie Tramel, and Howard Twilley.

Special thanks to my wife Amy and our son Lance who were patient with me as I stayed up all hours of the night and succumbed to the occasional (but temporary) fit of stress.

I can't forget my dad, Stan Bonham, who took me to my first TU Football game back in 1981 when I was 10 years old.

And most importantly, thank you God for blessing me with the opportunity to have enjoyed TU football for all of these years and for giving me a small measure of ability to write about it.

INTRODUCTION

The early 1980s were an exciting time to be around The University of Tulsa. Nolan Richardson had just led the Golden Hurricane to the National Invitational Tournament championship and a young coach named John Cooper had brought an exciting brand of football to Skelly Stadium.

I was pretty young at the time, but I remember those days well. My first TU football game was the opening game of the 1981 season against Kansas. I don't think I watched much of the game though. I was too busy playing with the miniature "gold" football that the cheerleaders had tossed into the stands. I used the tall hill that stretched from the top of the south end zone stands to the edge of 11th Street as my personal playground.

Later on, I learned to actually sit in the stands and appreciate the Golden Hurricane's winning ways. As a teenager, Hurricane standouts such as Michael Gunter, Ken Lacy, Steve Gage and Nate Harris became my personal heroes. But it wasn't until my freshman year at TU in 1989 when I really started to learn about the school's rich football tradition. Working in the sports information department, I was exposed to a wealth of knowledge. I discovered great players like Glenn Dobbs, Howard Waugh, Jerry Rhome, Howard Twilley, Willie Townes and Don Blackmon, just to name a few. There have been heralded coaches as well such as Sam McBirney, Francis Schmidt, Elmer Henderson, F.A. Dry and David Rader.

Now, with the resurgence that has been sparked by Coach Steve Kragthorpe, TU football fans look towards a promising future. So now seems to be a perfect time for looking back at the Golden Hurricane's glory years. I trust that you will enjoy reliving the memories of the distant past as well as the images of the 2003 season that excited and inspired us all.

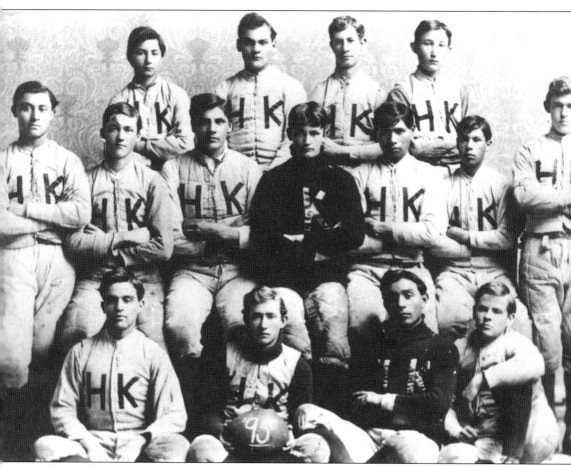

Kendall College fielded its first football team in 1895 for a one-game season. The squad defeated the Bacone Indians in a home contest played at Muskogee. Under the direction of Coach Norman Leard, the team went 5-2 between 1895 and 1897. (The University of Tulsa.)

ONE

Pioneers

1895–1940

If ever there was an excusable use of the cliché "humble beginnings," the story of The University of Tulsa and its football program might be a strong candidate. To understand just how far this small, private institution has come as both an academic stalwart and athletic force, it helps to know the history of the school itself.

It all started in 1882 as the Presbyterian School for Indian Girls located in Muskogee. In 1894, the school became known as Henry Kendall College. No one in Oklahoma should be surprised that college football preceded statehood. At Kendall College, the first team was assembled in 1895, 12 years before Oklahoma went from its status as part of the Indian Territory to a member of the Union. For the next three years, a man named Norman Leard coached the small squad to a 5-2 record. Kendall College continued its fledgling program for the next 13 years (the school did not field a team five of those years) and managed a respectable 11-11-1 record. It was during this time in 1907 when the school moved to Tulsa.

In his first and only season as head coach, George Evans led the 1913 squad to a promising 5-2 mark. The next year, a banker named Sam McBirney returned after a previous coaching stint in 1908 when the team went 2-3. Under his guidance, Kendall College saw its first glimpse of college football glory. From 1914 to 1916, McBirney and his team compiled a 23-3-1 record. The 1916 team went undefeated in 10 games and outscored its opponents 566-40.

"In 1916, there was a lot of agitation here to declare Tulsa the champion of Mid America," historian and noted Tulsa journalist Jenk Jones says. "They challenged Notre Dame to a game. This was three years after Notre Dame had its great coming out with Knute Rockne."

Despite some Tulsa businessmen's attempts to make history, that game against Notre Dame never took place. The foundation for future prominence, however, had been laid. Unfortunately, World War I interrupted the football program's progress. Kendall College struggled to put competitive teams on the field in 1917 and 1918 and posted a disappointing 1-10-1 record.

In 1919, Francis Schmidt, a former assistant to McBirney, returned from the war along with several key players including future TU Hall of Fame inductees John Young and Ivan Grove. Schmidt's first season at the helm produced great results. The team went 8-0-1 and won the Oklahoma Collegiate Conference title. Key victories included a 27-0 defeat of Oklahoma in Norman and a 63-7 trouncing of Arkansas in Fayetteville. Kendall College's only blemish was a 7-7 tie against Oklahoma State in Stillwater. The Kendallites were so dominant that season that they outscored the first three opponents 242-0. By the end of the season, they had tallied five shutouts and seven games with 60 points or more.

Schmidt and his squad added two games to the 1920 schedule and finished with a 10-0-1 record. Kendall College again took the conference title and was equally dominant. The team opened with a 121-0 victory over St. Gregory's and followed with a 151-0 blowout of Northeastern Oklahoma A&M. By season's end, Kendall College had outscored its opponents 621-21 including a 21-14 defeat of Oklahoma A&M. The 1919 and 1920 teams were collectively added to TU's Athletic Hall of Fame in 1997.

In 1921, Kendall College changed its name to The University of Tulsa. That season Schmidt recorded his worst coaching effort with a 6-3 record. Historians differ on their accounts of Schmidt's departure that year. Some believe that he left to take the coaching job at Arkansas. Others contend that he was fired for placing too much emphasis on winning. Whatever the reason, Schmidt left the school with a 24-3-2 record and the highest winning percentage among all TU coaches (.889). In 1971, Schmidt became Tulsa's first inductee into the College Football Hall of Fame.

Howard Acher succeeded Schmidt and continued the winning tradition with a 9-0 debut season in 1922. Tulsa again won the conference title and registered wins over Texas A&M, TCU and Arkansas. It was Acher who initially gave TU its nickname the Golden Tornadoes, which was later change to the Golden Hurricane due to the fact that Georgia Tech had already taken the other moniker. Acher struggled in his next two seasons winning just three games. He left after the 1924 season with an overall 12-11-2 mark.

TU shocked college football fans across the nation with the hiring of Elmer "Gloomy Gus" Henderson. A lucrative contract lured him away from the powerhouse program at the University of Southern California. Henderson's tenure was one of the most successful among TU coaches. His 10 consecutive winning seasons has yet to be matched and his 70 victories are likewise the most in school history.

The winning foundation was laid by a slew of great players that came through Henderson's program. Several future TU Athletic Hall of Fame inductees played during his 11-year career, including Roy Selby (1925–28), X. Elno Jones (1926–28), William Boehm (1929–32), Ishmael Pilkington (1930–31), William Volok (1931–33), Charles Dugger (1931–34), Roy "Skeeter" Berry (1932–34) and Ham Harmon (1934–36). Harmon joined Les Chapman and Tack Dennis as the first three players to be drafted into the fledgling National Football League.

Henderson's success on the field was only overshadowed by his role in the building of a new home for TU football. After 1919, McNulty Park provided an unusual backdrop for Tulsa's home games. It was actually a baseball field that measured only 90 yards. Once a team crossed the goal line, the ball was brought back to the 10-yard line where they had to get into the end zone a second time for the touchdown.

It took him five years, but Henderson's fundraising efforts finally paid off with the building of Skelly Stadium in 1930. It cost $300,000 to complete the 15,000-seat campus stadium. Named after local oil tycoon William G. Skelly, who donated $125,000 to the project, the facility originally had no end zone seating. The first game played there resulted in a 26-6 victory against Arkansas. End zone seating for 5,000 would be added in 1947. The major expansion of Skelly wouldn't take place until 1965.

After suffering his first losing season (3-6-1), Henderson left TU and was replaced by Vic Hurt. Hurt had put together solid credentials at SMU where he had won a Rose Bowl title. This hiring again showcased The University of Tulsa's ability to lure quality coaches. Hurt would leave in three years to take the Kansas job, but not before posting a respectable 15-9-5 record and three consecutive Missouri Valley Conference titles. Hurt led Tulsa to three victories against Oklahoma State and a 1937 win over Oklahoma.

As another decade came to an end, a familiar face returned to Tulsa for two seasons as head coach. Chet Benefiel had starred at the halfback position for the Golden Hurricane from 1928 to 1931. Benefield had actually been on campus ever since graduating in 1931. He served as Tulsa's head basketball coach from 1932 to 1939. He left that post to take over the football program for the 1939 season. In two years, Benefiel, a 1983 inductee into TU's Athletic Hall of Fame, compiled an 11-8-1 record.

Benefiel's most memorable season came in 1940 when he led Tulsa to a 7-3 record and the school's fifth MVC championship. More impressive was TU's 7-0 defeat of #7-ranked Detroit on the road and home victories against TCU (7-0) and Oklahoma State (19-6). His success would pave the way for one of the greatest eras in Tulsa football history.

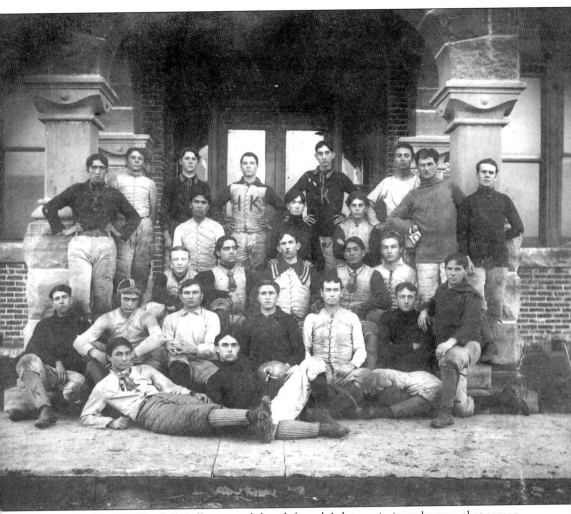

Pictured is the 1898 Kendall College squad that defeated Arkansas in its only game that season. Fred Taylor coached the team in both 1898 and 1899 leading the team to a 1-1-1 record. All three games were played against the Razorbacks. (The University of Tulsa.)

Pictured is Kendall College in action during the 1914 season. This was the third and final season in which the school played its home games at South Main Park. That year, the Kendallites went 7-2 and outscored its opponents 248-9. (The University of Tulsa.)

Pictured are Francis Schmidt (left) and Sam McBirney (right). McBirney coached Kendall College in 1908 and from 1914 to 1916. His four seasons resulted in a 24-6-1 record. Schmidt was an assistant coach under McBirney before serving as the head coach from 1919 to 1921. He compiled an impressive 24-3-2 mark including undefeated seasons in 1919 (8-0-1) and 1920 (10-0-1). McBirney was inducted into TU's Athletic Hall of Fame in 1991. Schmidt was enshrined as part of the 1993 class. (The University of Tulsa.)

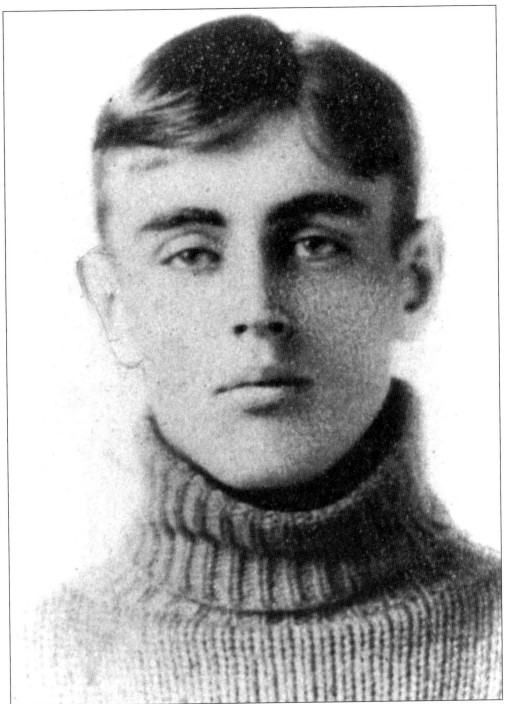

Madison "Puny" Blevins was an iron man tackle for Kendall College playing in all 27 games from 1914 to 1916. Contrary to his nickname, he towered over his teammates by nearly a foot. Blevins was named to the All-Oklahoma team in 1915 and 1916 and landed on both Oklahoma and Oklahoma A&M's All-Opponent teams in 1916. He was inducted into TU's Athletic Hall of Fame in 1983. (The University of Tulsa.)

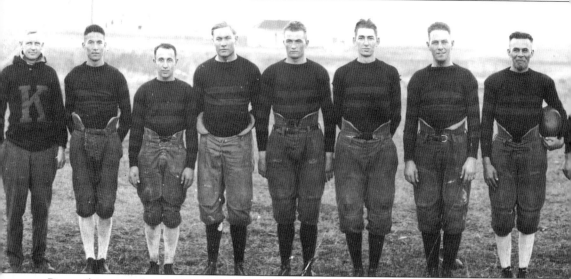

Pictured are members of Kendall College's 1916 team including TU Athletic Hall of Fame inductees Coach Sam McBirney (first from left), Rueben "Rube" Leekley (fourth from left),

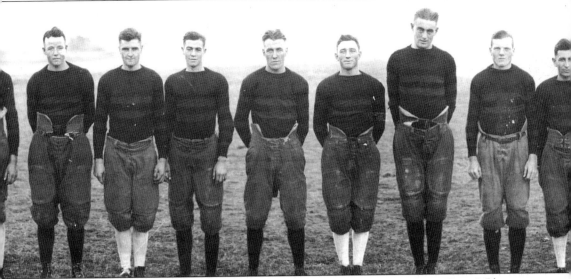

John Young (eighth from left), Ivan Grove (ninth from left) and Madison "Puny" Blevins (third from right). (The University of Tulsa.)

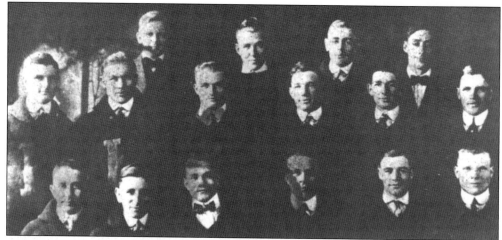

The 1916 team was named "Champions of Oklahoma and the Southwest" after a dominating 10-0 season. Kendall College outscored its opponents 566-40 including victories against Missouri-Rolla (117-0), St. Gregory (82-0), Cumberland (81-0), Oklahoma (16-0) and Oklahoma A&M (17-13). The 1916 team was inducted into TU's Athletic Hall of Fame in 1995. (The University of Tulsa.)

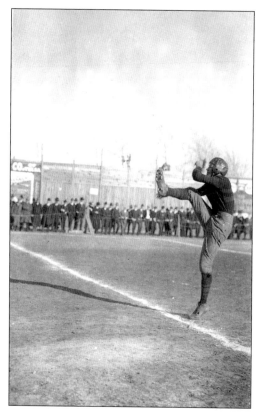

Ivan Grove was the quarterback for Kendall College from 1914 to 1916. He returned in 1919 to lead the nation in scoring with 196 points. Grove was named to both the All-Oklahoma and All-Southwest teams. In this photograph, he is shown performing his duties as the team's punter. (The University of Tulsa.)

Not only was Ivan Grove a four-year letterman on the football team, he also earned four letters in three other sports at Kendall College. His accomplishments earned him spots in both the Arkansas and Helms Foundation Halls of Fame. In 1982, Grove was part of the first group ever inducted into TU's Athletic Hall of Fame along with fellow football legend Glenn Dobbs and basketball standout Bob Patterson. (The University of Tulsa.)

Benton Springer was Kendall College's star halfback from 1917 to 1919. He was twice named to the All-Oklahoma team. Springer became a member of TU's Athletic Hall of Fame in 1996. (The University of Tulsa.)

17

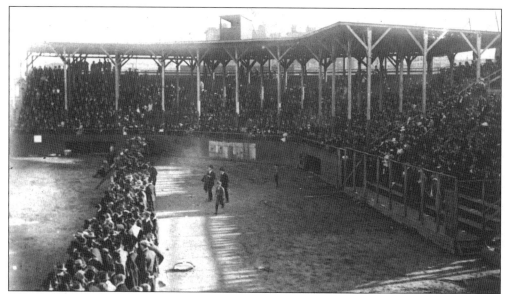

McNulty Park served as TU's home field from 1919 through 1929. It was actually a baseball stadium and only measured 90 yards in length. Therefore, when a team crossed the goal line, the ball was placed back at the 10-yard line where they were required to cross the goal line a second time for the touchdown. Pictured is a crowd of fans watching the first game played at McNulty Park on September 27, 1919. The Kendallites set the pre-1940 school record for points scored and margin of victory with a 152-0 pummeling of Oklahoma Baptist. (The University of Tulsa.)

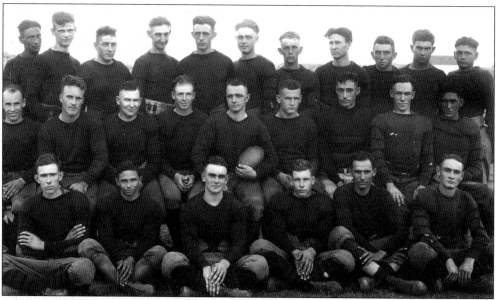

Pictured is Kendall College's 1920 team. The season's first three games produced a combined 360-0 drubbing of its opponents. The Kendallites allowed only 21 points the entire season en route to a 10-0-1 record and a second consecutive Oklahoma Collegiate Conference title. In 1971, Coach Francis Schmidt became TU's first inductee into the College Football Hall of Fame. (The University of Tulsa.)

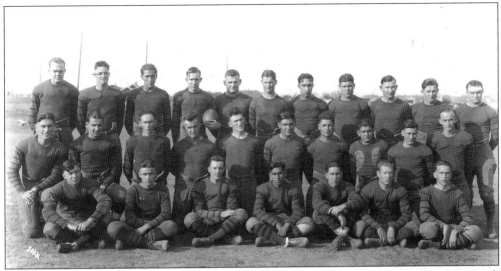

Howard Acher took over the coaching reigns and led the 1922 team to a perfect 9-0 record. Kendall College was renamed The University of Tulsa a year earlier and midway through the 1922 season, Acher renamed the team "the Golden Tornadoes" after a rousing 21-0 victory over TCU. When TU later discovered that Georgia Tech was already using that name, the team picked the next best natural disaster and became known as "the Golden Hurricane." (The University of Tulsa.)

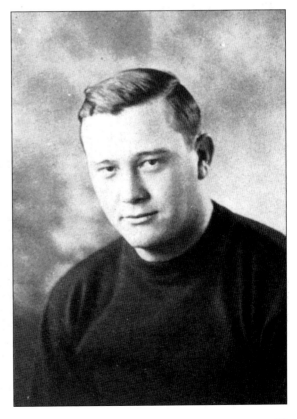

Murl "Tuffy" Cline played quarterback for TU from 1923 to 1926. In his last two seasons, the Golden Hurricane posted a 13-4 record and won the 1925 Oklahoma Collegiate Conference title. In 1926, Cline led TU to a 7-2 mark including a 28-0 victory over Oklahoma A&M and a 14-7 victory over Arkansas. He was selected to the All-Oklahoma team two years straight. In 1988, Cline was enshrined into TU's Athletic Hall of Fame. (The University of Tulsa.)

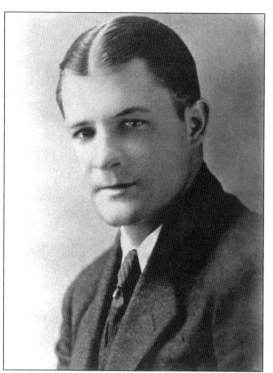

X. Elno Jones played for Tulsa from 1926 to 1928. Jones excelled as a pass rusher on the defensive line and was named to the All-Oklahoma team in 1927 and 1928. During his career, TU recorded a 22-5-1 mark including three consecutive victories against Oklahoma A&M. He also earned three letters in basketball. Jones was named to TU's Athletic Hall of Fame in 1984. (The University of Tulsa.)

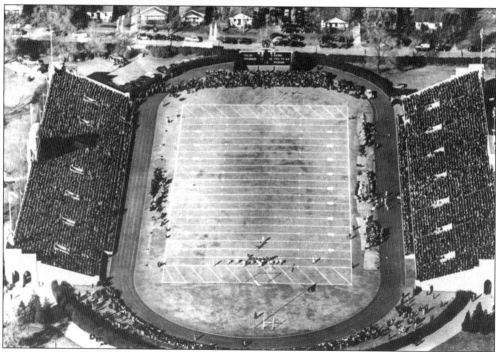

On October 4, 1930, the Golden Hurricane played its first game at Skelly Stadium on the campus of The University of Tulsa. Named after local oil mogul William G. Skelly who donated $125,000 to the project, the stadium's initial configuration could hold 15,000 fans. Tulsa christened Skelly Stadium with a 26-6 victory over Arkansas. (The University of Tulsa.)

Ham Harmon was a two-way lineman for the Golden Hurricane from 1934 to 1936. He was the team captain in 1936 and earned honorable mention All-America honors that same year. Harmon was twice named All-MVC as an offensive center. He was a fifth round NFL draft pick of the Chicago Cardinals. Harmon was inducted into TU's Athletic Hall of Fame in 1986. (The University of Tulsa.)

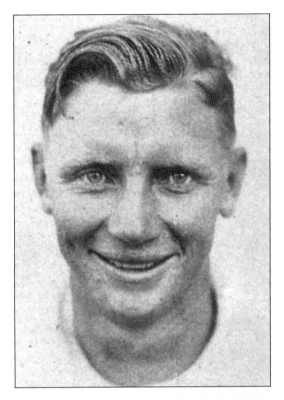

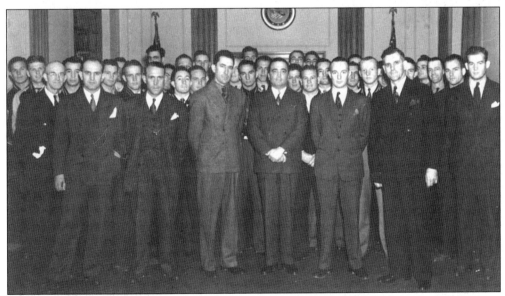

Pictured is Tulsa's 1937 Missouri Valley Conference championship team visiting FBI Director J. Edgar Hoover at the FBI headquarters in Washington DC. The Golden Hurricane went on to defeat George Washington University 14-13 during the trip and finished the season 6-2-2. Other key games that year included a 19-7 victory against Oklahoma and a 27-0 victory against Oklahoma State. Head Coach Vic Hurt compiled a 15-9-5 record during his three-year stint. (The University of Tulsa.)

In 1938, this unidentified horse was named the Golden Hurricane's new mascot. That season, Coach Vic Hurt suffered the only losing season of his three-year career with a 4-5-1 record including a 21-0 loss to top-ranked TCU and a 28-6 loss to number 11 Oklahoma. Tulsa did manage to defeat Oklahoma State, 20-7, and capture the Missouri Valley Conference title. (The University of Tulsa.)

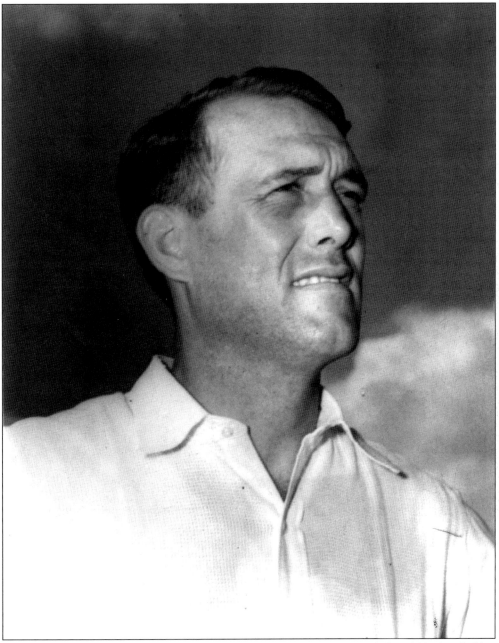

From 1939 to 1940, Coach Chet Benefiel led TU to an 11-8-1 record. In 1940, the Golden Hurricane upset #17 Detroit on the road and won the MVC title. Benefiel left his biggest mark on the program as a halfback from 1928 to 1931. He was named Oklahoma Back of the Year in 1929 and was named an honorable mention to the 1930 All-American team. Benefiel also spent seven years coaching the basketball team from 1932 to 1939. In 1983, he was inducted into the TU's Athletic Hall of Fame. (The University of Tulsa.)

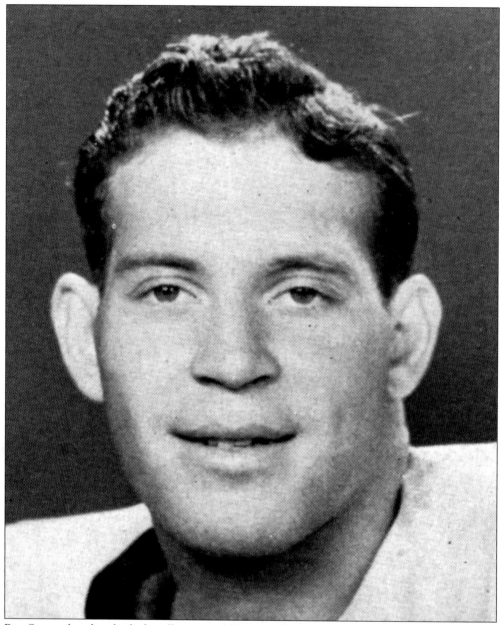

Roy Stuart played on both the offensive and defensive lines for TU from 1939 to 1941. He played in the school's first bowl game, the 1941 Sun Bowl, and was voted as the game's most outstanding lineman. In 1945, Stuart was named to TU's All-Fifty Year Golden Hurricane football team. He was enshrined into TU's Athletic Hall of Fame in 1993. (The University of Tulsa.)

TWO

Glory Years

1941–1960

By the time new head coach Henry Frnka arrived on campus, TU had already proven itself to be a consistent mainstay in the growing realm of college football. But nothing could prepare the city of Tulsa for what it was about to experience.

It all started in 1941 with Frnka's first season at the helm. The Golden Hurricane lost its first game that season, a 6-0 defeat at the hands of TCU. Frkna's group rebounded for seven straight victories including key games against Oklahoma State (16-0) and Baylor (20-13). After a heartbreaking 13-6 loss to Arkansas at Skelly Stadium, most felt like Tulsa had lost its opportunity for a bowl game. Instead, TU found itself headed to El Paso, Tex., for a meeting with Texas Tech at the Sun Bowl. Tulsa won the game with just minutes remaining as Glenn Dobbs connected with Sax Judd for a 32-yard touchdown play. The Golden Hurricane's first bowl trip resulted in a 6-0 victory and the team finished the season, 8-2.

In 1942, Frnka's team truly became a dominant force shutting out its first six opponents. Tulsa defeated Oklahoma (23-0), Oklahoma State (34-6) and Arkansas (40-7) en route to a perfect 10-0 regular season. Tulsa led the nation in passing offense (233.9 yards per game), scoring offense (42.7 points per game) and scoring defense (3.2 points per game).

The season culminated with a trip to New Orleans for a matchup against seventh-ranked Tennessee at the prestigious Sugar Bowl. In another defensive struggle, Tulsa gave up a fourth quarter touchdown and lost the game, 14-7. Had TU won, the Golden Hurricane would have been a strong candidate for a national championship. Instead, Tulsa received a number four ranking, the highest in school history.

There were many great players who donned the Golden Hurricane uniform in those first two seasons under Frnka, but none greater or more revered than Glenn Dobbs. He played several positions for the Golden Hurricane including quarterback, punter and defensive back. In 1942, his 48.3 punting average was the nation's best but was four punts shy of qualifying for the national title. That same year, he recorded a pass efficiency rating of 138.8 that still stands fifth among TU's all-time best. Dobbs completed 67 of 107 passes for 1,066 yards and threw just four interceptions. He made up for those miscues by leading the team with four picks of his own. In 1980, Dobbs became Tulsa's second inductee into the College Football Hall of Fame.

"(Glenn Dobbs) was the true triple threat," Tulsa historian and journalist Jenk Jones says. "I saw him play in his mid-thirties against the varsity in an alumni game. He had four punts of 70 yards or better and four touchdown passes."

Howard Twilley played for Glenn Dobbs in the early 1960s and regrets never having had the opportunity to watch his coach and mentor in action. "I wish that I could have been transported in time and saw Glenn play because he was a heck of a player," Twilley says.

Other future TU Athletic Hall of Fame members from those teams included Sax Judd (1940–42), Cal Purdin (1940–42) and N.A. Keithley (1940–42). Purdin and Judd were Tulsa's leading receivers and Keithley represented the primary rushing threat. Along with Dobbs, they all went on to have NFL careers.

By 1943, all of those players were gone but Frnka still had a stockpile of talent. Tulsa played

a shortened seven-game schedule that year and again completed a sweep of the area teams with wins against Oklahoma (20-6), Oklahoma State (55-6) and Arkansas (61-0). With a 6-0-1 record, the Hurricane was once again invited to play in the Sugar Bowl. This time the team would face 13th-ranked Georgia Tech. Led by future TU Hall of Fame inductee Clyde LeForce, Tulsa took a commanding 18-7 halftime advantage only to see it disappear as the Yellow Jackets reeled off 13 unanswered points for the 20-18 victory. The Golden Hurricane earned a number 15 ranking in the final Associated Press polls.

The 1944 season included a number of marquis matchups. Tulsa opened up with four straight victories including Kansas (27-0), Texas Tech (34-7) and Mississippi (47-0). The Golden Hurricane had a rare lapse with back-to-back losses against Oklahoma State and sixth-ranked Iowa Pre-Flight. Tulsa would rally to win its final three games highlighted by a home win against Arkansas (33-2) and a defeat of Miami on the road (48-2).

Tulsa's 7-2 record was good enough to earn the team a spot in the Orange Bowl. It was a rematch from the previous year's Sugar Bowl against Georgia Tech. Once again, the Yellow Jackets were ranked 13th in the nation and poised to put the unranked Golden Hurricane in its place. But TU had revenge on their mind and took control of the game from the beginning. Tulsa led 20-0 before Georgia Tech finally found its way to the end zone. On the ensuing kickoff, Camp Wilson took the ball and ran it back 90 yards for the score. As the final gun went off, Tulsa had secured a convincing 26-12 victory.

Along with Wilson, two more future TU Hall of Fame inductees starred for the Golden Hurricane. Ellis Jones played from 1942 to 1944 at the guard position. Amazingly, this one-armed athlete earned First Team All-America honors in 1944 and was drafted by Boston in the 1945 NFL draft. Clyde Goodnight was another TU player from those teams that went on to have a successful pro career. He played for Frnka on the bowl teams of 1942, 1943 and 1945.

In Frnka's final season, Tulsa's only two regular season losses came against eighth-ranked Indiana (7-2) and 11th-ranked Oklahoma A&M (12-6). With an 8-2 record, Tulsa received its fifth-straight bowl game invitation to face eighth-ranked Georgia at the Oil Bowl in Houston, Texas. Trailing 7-6 through three quarters, Tulsa gave up two late touchdowns en route to the 20-6 loss. TU still managed to receive a number 17 ranking in the final polls with its 8-3 record.

By the time Frnka's five-year career came to an end, he not only compiled a 40-9-1 record, he managed to do what no other TU coach has been able to duplicate. All of his teams played in bowl games and in fact, Tulsa made history by becoming the first school to play in five consecutive New Year's Day bowls. Frnka also coached three Consensus First Team All-Americans (Glenn Dobbs in 1942, Felto Prewitt in 1944 and Ellis Jones in 1945).

When faced with the dubious task of following in Frnka's footsteps, first-year head coach J.O. Brothers didn't flinch. Instead, he simply carried on the tradition with a dominant 9-1 season. With victories against Texas Tech, Kansas, Oklahoma State and 10th-ranked Arkansas, a bowl game was seemingly in order for the 1946 Golden Hurricane. Still, Tulsa was left with only a MVC title and a number 17 national ranking to show for its outstanding play.

In 1947, Tulsa's seven-year string of winning seasons was snapped by a 5-5 performance. TU still managed to run the table in the MVC and more importantly, scored a 13-0 defeat of in-state rivals Oklahoma State. Jenk Jones attended the game and remembers exactly how the Golden Hurricane pulled off the upset.

"Tulsa was a definite underdog," Jones recalls. "They came out and surprised Oklahoma State with a sleeper play on the first play. That was an old thing that you can't get away with today. You trot your team out on the field and one of the receivers would stay very close to the sideline and the other team didn't notice him. They'd snap the ball and of course he'd go down the field with nobody on him. TU didn't actually score on the play but they drove deep into Oklahoma State territory and had them off balance for the rest of the game."

Tulsa suffered through a rare no-win season in 1948, finishing 0-9-1. Brothers bounced back the next season to go 5-5-1. That 1949 season saw the birth of a short-lived, but compelling series between TU and Villanova. The first meeting took place in Philadelphia where the 17th-

ranked Wildcats were a 33-point favorite. According to Jenk Jones, Villanova was "considered the best team in the East and were supposedly headed for the Sugar Bowl." Tulsa played the role of the spoiler with the 21-19 upset.

Even in the off years, Tulsa maintained a high level of talent on the field. Players like Jerry D'Arcy and Nelson Greene joined TU's squad during the Frnka era but had their careers interrupted by World War II. James Finks starred at the quarterback position from 1946 to 1948 and was twice named All-MVC. His NFL playing career coupled with the success he saw as a general manager earned him a spot in the Pro Football Hall of Fame.

Hardy Brown was another one of the many characters that shared in the TU football legacy. Brown anchored TU's defense from 1945 to 1947. His key defensive stop preserved the 1946 victory against Arkansas. In the NFL, Brown became notorious for his vicious tackling style.

"He was a master of coming up under a guy's chin with his shoulder pads and just knocking him out," Jenk Jones says. "He laid people out all over the place. When Hardy played, no one wanted to return punts because he would just level people."

From 1950 to 1952, Brothers brought TU back to national prominence. In 1950, Tulsa went 9-1-1 with victories against Oklahoma State (27-13), Texas Tech (39-7) and Arkansas (28-13). Despite a number 19 national ranking, the Golden Hurricane were once again denied the chance to play in a bowl game. The 1951 season was another successful year as Tulsa lost only to Cincinnati and Arkansas en route to its 9-2 mark. TU also led the nation in total offense averaging 480.1 yards per game.

In his sixth and final season, Brothers finally led Tulsa to that elusive bowl game. TU struggled early on with a 14-14 tie against Cincinnati followed by a lopsided 33-7 loss on the road at the hands of the Houston Cougars. But the Golden Hurricane reeled off seven straight wins including Brothers' fifth defeat of Oklahoma State in seven tries as well as a 44-34 victory over Arkansas.

Tulsa headed to Jacksonville, Florida, to face off against 15th-ranked Florida in the Gator Bowl. With the majority of the 30,000 in attendance rooting for the Gators, TU fought back from a 14-0 halftime deficit. Howard Waugh's fourth-quarter touchdown drew Tulsa to within one point but Tom Miner's extra point was no good. The Golden Hurricane still had a chance to win the ball game, but Miner missed a 21-yard field goal attempt and Florida escaped with the 14-13 win. TU ended the season 8-3 and the number 12 national ranking.

Those three years saw the emergence of several future TU Athletic Hall of Fame inductees. Howard Waugh became one of Tulsa's most prolific rushers with back-to-back 1,000-yard seasons. In 1952, he led the nation with 1,372 yards on 164 carries. That performance ranks second in school history and his 2,597 career yards ranks third all-time. Other star players included lineman Marvin Matuszak who went on to play for the Pittsburgh Steelers, prolific passing quarterback Ronnie Morris, Canadian Football Hall of Fame member Kaye Vaughan and Tommy Hudspeth, former coach at BYU, UTEP, the Detroit Lions and the Toronto Argonauts.

In 1953 and 1954, Tulsa went 3-18 under the coaching tenure of Bernie Witucki. TU's 0-11 record in 1954 prompted a change in leadership. Bobby Dobbs, the brother of Glenn Dobbs, was tabbed as the man to turn the program back around. Never able to sustain back-to-back winning seasons, Dobbs lead the Golden Hurricane to its best records in 1956 (7-2-1) and 1958 (7-3). That latter season included big wins at Arkansas (27-14) and Houston (25-20) as well as impressive victories at Skelly Stadium over Arizona (34-0), Oklahoma State (24-16) and Texas Tech (9-7). In both 1959 and 1960, TU went 5-5. The highlight of the 1959 season was a 17-6 upset of 16th-ranked North Texas State. Dobbs left the head coach's post with a combined 30-28-2 record.

Two of the more popular players during Dobbs' coaching career were Bob Brumble and Jerry Keeling. Brumble played from 1957 to 1959 and earned two All-MVC honors at the fullback position. Jerry Keeling was a star quarterback from 1958 to 1960. As a senior, he completed an 85-yard touchdown pass to Bill Gary against Wichita State, the fourth longest in school history. That same year, he tossed an 80-yard bomb to Bobby McGoffin in a loss to Oklahoma State, the seventh longest by a TU quarterback. Keeling went on to a successful CFL career including his induction into the Canadian Football Hall of Fame.

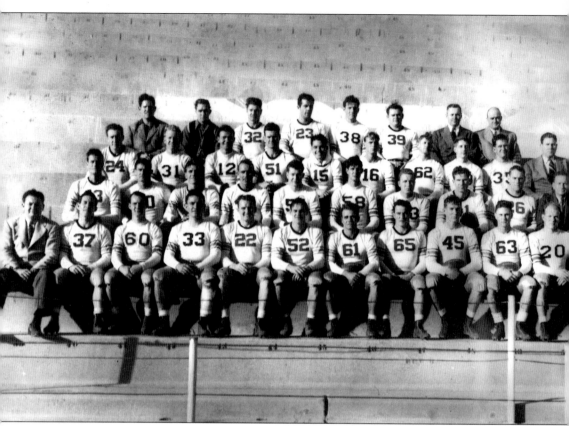

The 1941 Golden Hurricane squad became the first in school history to earn a bid to a bowl game. Under the direction of first-year coach Henry Frnka, Tulsa defeated Texas Tech 6-0 on January 1, 1942 and finished the season 8-3. TU boasted six All-Missouri Valley Conference performers including Glenn Dobbs, N.A. Keithley, Sax Judd, Charles Greene, Rich Morgan and Elston Campbell. Wayne Holt, Glenn Henicle and Greene were each selected as part of the 1942 NFL draft. (The University of Tulsa.)

Arguably the greatest player in TU history, Glenn Dobbs played from 1940 to 1942 as a quarterback, tailback, punter, and defensive back. In 1942, he led the nation in punting with a 48.3 average and was named a First Team All-American. In his career, he launched four punts of 75 yards or more including an 87-yard boot against Oklahoma in 1942. That same year, he spent significant time on defense and led TU with four interceptions. Dobbs also recorded the fifth best single season passing efficiency rating in TU history of 138.8. A three-time All-MVC player, Dobbs continued his playing career as a first round NFL draft selection of the Chicago Cardinals. He was inducted into the College Football Hall of Fame in 1980 and the TU Athletic Hall of Fame in 1982. Dobbs' number 45 jersey is retired. (The University of Tulsa.)

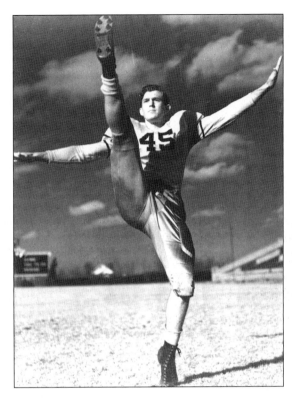

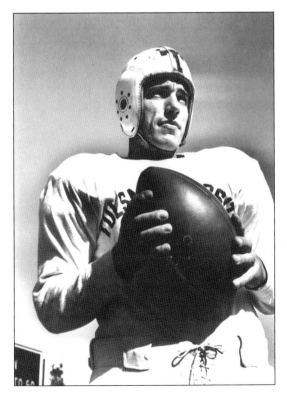

N.A. Keithley played tailback for Tulsa from 1940 to 1942. He led the Hurricane in rushing as a junior and senior while earning First Team All-MVC honors. The New York Giants selected Keithley as their 14th-round pick in the 1943 NFL draft. He was inducted into TU's Athletic Hall of Fame in 2002. (The University of Tulsa.)

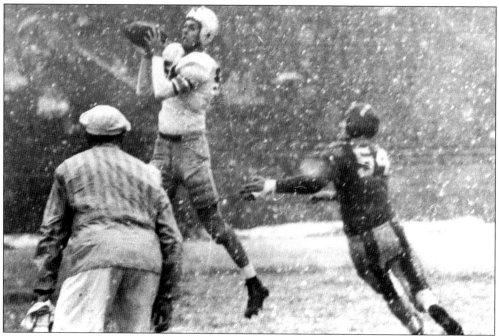

On October 18, 1941, TU defeated St. Louis, 33-7, in a snow-covered Skelly Stadium. It was Tulsa's second Missouri Valley Conference victory of the season en route to a perfect 4-0 record and subsequent conference title. TU competed in the MVC from 1935 to 1985 and won 25 championships over a 51-year span. The MVC disbanded its football conference following the 1985 season. (The University of Tulsa.)

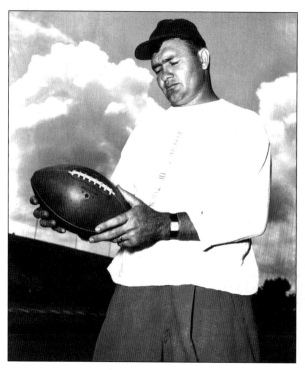

Saxon "Sax" Judd was a leading receiver and dominant defensive end for TU from 1940 to 1942. He played a major role in the Golden Hurricane's first two bowl games, the 1941 Sun Bowl and the 1942 Sugar Bowl. In 1942, he led TU in receiving with 35 catches for 509 yards and nine touchdowns. A two-time All-MVC selection, Judd was a third round NFL draft pick of the Chicago Cardinals. He was inducted into TU's Athletic Hall of Fame in 1986. (The University of Tulsa.)

Cal Purdin was a running back and receiver for TU from 1940 to 1942. He led Tulsa in scoring in 1941 with five touchdowns for 30 points. Purdin was also the team's leading receiver that year with 13 receptions for 217 yards. In 1942, he earned All-MVC honors. Purdin also lettered in basketball and track. In 1943, the Chicago Cardinals selected him in the 25th round of the NFL draft. Purdin was inducted into TU's Athletic Hall of Fame in 1990. (The University of Tulsa.)

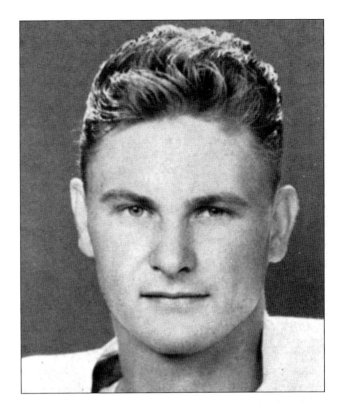

Pictured is Coach Henry Frnka in late 1942 prior to TU's appearance in the 1943 Sugar Bowl. Frnka took the reigns in 1941 and led the Golden Hurricane to five consecutive New Year's bowl games during his tenure. TU was the first college to achieve that feat. Frnka's teams won three MVC titles and led the nation in passing in 1942 and 1944. TU obtained its highest national ranking in 1942 when the team went 10-1 and was voted fourth by the Associated Press. The Golden Hurricane's only blemish that season was a 14-7 defeat at the hands of seventh-ranked Tennessee in the Sugar Bowl. Frnka is the second winningest coach in TU history with a .819 winning percentage (40-9-1). He was inducted into TU's Athletic Hall of Fame in 1983. (The University of Tulsa.)

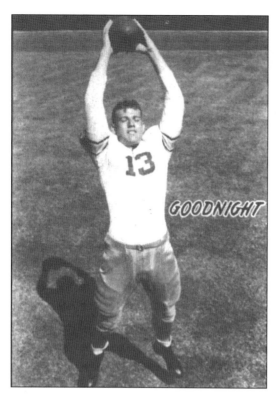

Clyde Goodnight excelled as both a receiver and a defender from 1942 to 1944. He was twice named an All-America honorable mention. Goodnight was the second-round selection of the Green Bay Packers in the 1945 NFL draft. He was inducted into TU's Athletic Hall of Fame in 1989. (The University of Tulsa.)

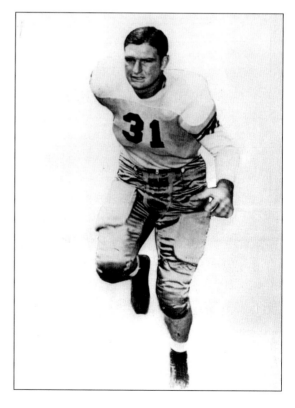

Ellis Jones played offensive and defensive tackle for TU from 1942 to 1944. Even more amazing than his dominant play on both sides of the ball was the fact that he did so with just one arm. In 1944, Jones earned First Team All-America honors and in 1945, Boston drafted him in the eighth round of the NFL draft. His number 31 jersey is retired and he was inducted into TU's Hall of Fame in 1983. (The University of Tulsa.)

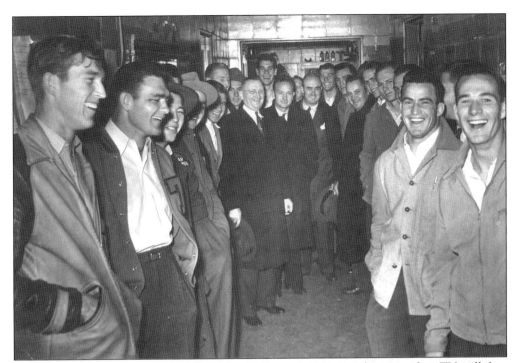

Pictured are players and coaches from the 1942 team receiving the news that TU will face seventh-ranked Tennessee in the Sugar Bowl. (The University of Tulsa.)

Pictured is the cover of the Sugar Bowl game program from January 1, 1943. TU and number seven. Tennessee battled before 70,000 fans in New Orleans, LA. After taking a 7-6 lead into the locker rooms at halftime, TU succumbed to the Volunteers' powerful rushing game and stalwart defense. Tennessee shutout TU in the second half and scored eight unanswered points for the 14-7 victory. (The University of Tulsa.)

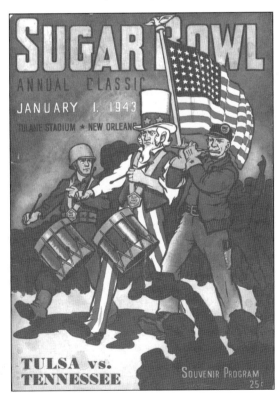

33

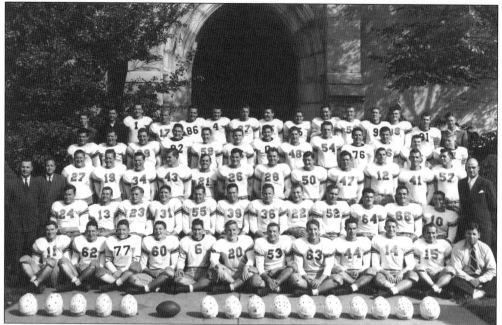

In 1944, Tulsa recorded an 8-2 mark including victories against Kansas, Texas Tech, Mississippi, Arkansas and Miami. The season culminated with TU's fourth consecutive New Year's Day bowl appearance. At the Orange Bowl, the Golden Hurricane dominated #13-ranked Georgia Tech winning by a final score of 26-12. (The University of Tulsa.)

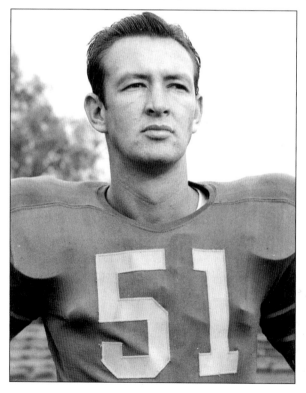

Jerry D'Arcy played center for Tulsa in 1942 before his Air Force service during World War II interrupted his college football career. He returned to the team for the 1946 and 1947 seasons. After a brief NFL career with the Philadelphia Eagles, D'Arcy came back to Tulsa as an assistant coach in 1949. He also coached the baseball team for three seasons. D'Arcy was inducted into TU's Athletic Hall of Fame. (The University of Tulsa.)

Nelson Greene played on both the offensive and defensive lines for Tulsa in 1942. Like D'Arcy, he too spent three years in the military with the Marines before finishing his football career from 1946 to 1947. Greene was named to the All-MVC team as a junior and a senior. The New York Giants selected him with their third-round pick of the 1947 NFL draft. He was inducted into TU's Athletic Hall of Fame in 1999. (The University of Tulsa.)

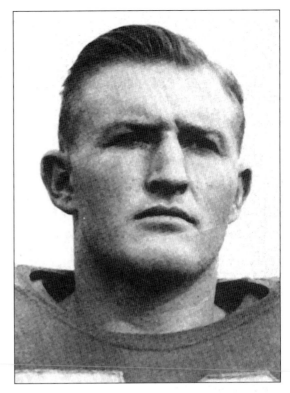

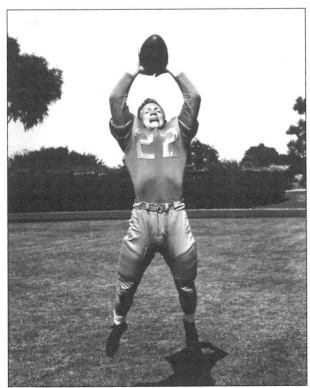

J.R. Boone played halfback for TU from 1944 to 1947. As a senior, he led Tulsa with 661 rushing yards on 125 carries for a 5.3 average. He was also the team's leading scorer and kickoff return man. Boone lettered three times in basketball and once each in basketball and track. He was added to TU's Athletic Hall of Fame in 1999. (The University of Tulsa.)

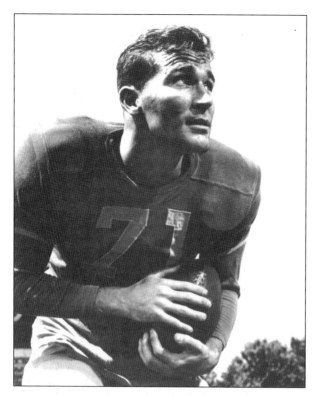

Hardy Brown played halfback and linebacker for TU from 1945 to 1947. He also spent three years as the team's punter averaging 38 yards per kick. Brown was named First Team All-MVC in both 1945 and 1946. He was added to TU's Athletic Hall of Fame in 1994. (The University of Tulsa.)

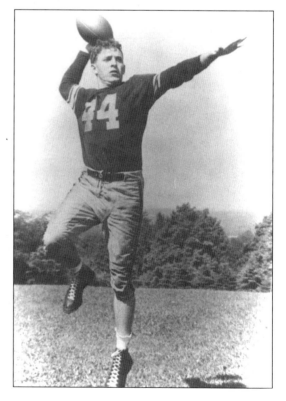

Jim Finks played quarterback for TU from 1946 to 1948. As a senior, he was the nation's second leading passer with 1,363 yards and seven touchdowns. Finks also completed 53 percent of his passes that season. His 83-yard run against West Texas State in 1947 ranks fourth among the longest running plays in TU history. Finks spent five years in the NFL with Pittsburgh and went on to serve as the general manager for Minnesota, Chicago and New Orleans. He was inducted into TU's Athletic Hall of Fame in 1987 and the Pro Football Hall of Fame in 1995. (The University of Tulsa.)

Rogers Lehew was a four-year letterwinner for Tulsa from 1946 to 1949. As a guard, he was one of only two freshmen to make the varsity team in 1946. Lehew went on to serve as the general manager for the Calgary Stampeders and was also the vice president and assistant GM for the Detroit Lions. He was inducted into TU's Athletic Hall of Fame in 1997. (The University of Tulsa.)

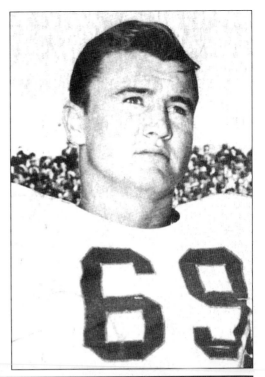

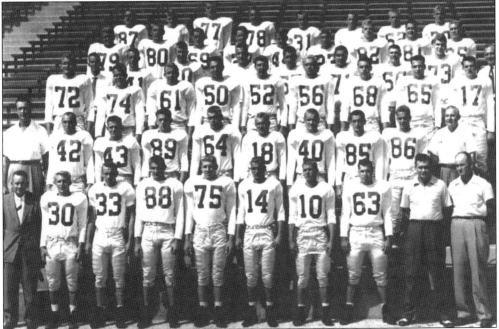

In 1952, TU hailed the nation's best offense with 466.6 yards per game. Tulsa also boasted the nation's top running back in Howard Waugh who gained 1,372 yards on 164 carries. Under the guidance of head coach J.O. "Buddy" Brothers, the Golden Hurricane rode the back of its offense all the way to an 8-2-1 record and Gator Bowl appearance. Key victories included home defeats of Oklahoma State, Arkansas and Villanova. (The University of Tulsa.)

Marvin Matuszak played for TU from 1950 to 1952 and is considered by many to be the top lineman in school history. He is the only Golden Hurricane to receive First Team All-America honors in two different seasons (1951 and 1952 by the Associated Press). Matuszek was twice named to the All-MVC team and was co-captain of the 1952 Gator Bowl team. He spent several years in the NFL playing for the Pittsburgh Steelers and the Atlanta Falcons. Matuszak's #64 jersey is retired and he was inducted into TU's Athletic Hall of Fame in 1983. (The University of Tulsa.)

From 1950 to 1952, Howard Waugh set a new standard for TU running backs. His 2,597 career rushing yards ranks third in school history. In 1952, he led the nation in rushing with 1,372 yards and an average of 8.4 yards per carry. For his career, Waugh averaged 7.4 yards per carry and tallied 10 games of more than 100 yards rushing including a 250-yard performance against Arkansas in 1952 and a 216-yard performance against Houston in 1951. The Los Angeles Rams drafted him into the NFL with a sixth-round selection. Waugh, a two-time All-MVC performer, was inducted into TU's Athletic Hall of Fame in 1983. (The University of Tulsa.)

After the University of San Francisco dropped its football program, Bob St. Clair transferred to Tulsa in 1952 for his senior season. He earned Second Team All-MVC honors and is considered one of the greatest defensive tackles to play for the Golden Hurricane. St. Clair enjoyed a long NFL career with the San Francisco 49ers including five Pro Bowl appearances. In 1991, he was inducted into both TU's Athletic Hall of Fame and the Pro Football Hall of Fame. (San Francisco 49ers/The University of Tulsa.)

Kaye Vaughan was a star tackle for TU from 1950 to 1952. He spent 12 years with the Ottawa Rough Riders and was a CFL All-Star 10 times. Vaughan was inducted into the Canadian Football Hall of Fame in 1978 and enshrined into TU's Athletic Hall of Fame in 1990. (The University of Tulsa.)

Ronnie Morris was TU's starting quarterback from 1950 to 1952. He was named an All-MVC performer all three years and compiled 4,422 yards of total offense. In 1952, he led the nation with a 177.4 pass efficiency rating. That rating is the best single-season mark in TU history and his 142.3 career mark is second only to Jerry Rhome. In 1988, Morris was inducted into TU's Athletic Hall of Fame. (The University of Tulsa.)

From 1950 to 1952, Tommy Hudspeth started every game for TU as a defensive back. He went on to a lengthy coaching career with Brigham Young, UTEP, the Detroit Lions and the Toronto Argonauts. Hudspeth was inducted into TU's Athletic Hall of Fame in 1993. (The University of Tulsa.)

Bob Brumble played fullback for TU from 1957 to 1959. He was twice named to the All-MVC First Team and led the Hurricane in rushing as a senior with 599 yards. As a junior, he scored eight touchdowns to pace all TU players. In 2002, Brumble's name was added to the rolls of TU's Athletic Hall of Fame. (The University of Tulsa.)

Jerry Keeling was a three-year starting quarterback from 1958 to 1960. He completed 189 passes for 2,468 yards and 20 touchdowns and was twice named First Team All-MVC. Keeling went on to play for the Calgary Stampeders where he played on two Grey Cup Championship teams. He was named to both the Canadian Football Hall of Fame and the TU Athletic Hall of Fame in 1989. (The University of Tulsa.)

THREE

Passing Fancy
1961–1976

In 1961, TU football's elder statesman returned to his alma mater to take over as head coach. Glenn Dobbs replaced his brother Bobby who had led the Golden Hurricane to a respectable 30-28-2 record over six seasons. As revered as Dobbs was as a player, no one anticipated just how significant his second stint with the program would be.

Dobbs didn't have the greatest start going 2-8 in his coaching debut. The 1962 team faired better with a 5-5 record and a 3-0 MVC mark that was good for the conference crown.

The 1963 season saw the making of an unlikely hero and future college football legend. Howard Twilley says the biggest defining moment in his life came during his junior year in high school. The Houston, Texas native was still playing on the junior varsity team when he volunteered to play receiver in a scrimmage against the varsity. It didn't take long into the contest before his coaches discovered that Twilley had a special talent for catching passes.

"I grew up with Southwest Conference football," Twilley says. "That was where I wanted to go. I'd never even heard of The University of Tulsa. I also didn't get any other scholarships so I was interested in anybody who was interested in me."

In those days, freshmen were required to sit out a year and would usually play on a junior varsity squad instead. The previous season, Twilley had shown sparks of greatness throughout the short schedule and had even played in a scrimmage against the varsity along with redshirt transfer Jerry Rhome. But for all those early memories, Twilley says his first encounter with head coach Glenn Dobbs is one that left the strongest impression.

"I will never forget the first time I saw Glenn Dobbs," Twilley says. "I will never forget it as long as I live. I had to fill out a little questionnaire about how big I was and I had fudged a little on how big I was. And I remember Glenn coming out and he's a big, imposing guy. He's like six-five and I'm only about five-nine at the time and he says, 'are you Twilley?' And I said, 'yes sir.' And he kind of looks me up and down and says, 'well I guess you'll do.'"

That one statement lit a fire under Twilley and he immediately set out to prove Dobbs wrong. "I got so motivated," Twilley says. "I was in tremendous shape when I came to the university that fall to be a freshman."

In 1963, another star emerged in the form of quarterback Jerry Rhome. After sitting out a year due to his transfer from SMU, Rhome spent his junior season splitting duties with Billy Van Burkleo. By the end of the year, it was clear that Rhome was on a history-making path. Dobbs and assistant coach F.A. Dry had been implementing a new offense that focused on the passing attack. Both were instrumental in a system that would revolutionize college football.

"Glenn was responsible for the overall direction of the football team," Twilley says. "Glenn was very much ahead of his time. They talk about the West Coast offense today. We ran the West Coast offense when I was at Tulsa. Basically, the West Coast offense is throw short passes and let people run and when they try to stop that, you throw vertical down the field. Glenn was much ahead of his time in terms of designing a possession type passing game. We could make first downs by throwing the football as easily as running the football."

In 1963, Tulsa again recorded a 5-5 mark. Rhome and Twilley were starting to show signs of greatness, but the real offensive explosion was right around the corner. After practices and during the offseason, the two players would spend hours working on routes and developing a keen sense of timing. That work ethic along with some other key factors played into the next year's cosmic leap.

"Jerry Rhome was a much better quarterback in 1964," Twilley says. "He was much more confident. He wasn't worried about losing his job. We got some great football players. We got Willie Townes and he was a great football player. Our defense became much more of a factor."

Midway through the season, Tulsa stood at 3-2 with its only losses coming against Arkansas and Cincinnati. The Golden Hurricane prepared to host in-state rivals Oklahoma State. TU had lost its last five games against the Cowboys and most experts expected the streak would not likely end that day. Not only did the streak end, Tulsa had one of its most explosive outings in modern history. Rhome completed 35 of 43 passes for 488 yards and four touchdowns. His performance still stands as the second best in TU history. Twilley was the recipient of 15 of those passes. He finished the game with 217 yards, the 14th best receiving day for any TU player.

"It was probably the greatest football game The University of Tulsa has ever played," Twilley says. "That's pretty bold because Tulsa's played some great games back in the forties. We were a seven-point underdog. Oklahoma State had just come off a victory against Missouri. It was a game where we were very confident. OSU didn't have a very good defensive scheme against what we were doing. They were ready to stop the option. If we had run the option, they would've stopped it. The problem is, we didn't run the option. OSU had a bad day. They fumbled the ball a bunch of times and we just had a day of days."

The 61-14 victory over Oklahoma State catapulted TU through the rest of its season. Having won five games in a row, the Golden Hurricane received an invitation to the Bluebonnet Bowl in Houston, Texas, to face Mississippi. According to former Tulsa Tribune sports writer Jenk Jones, the contest should be referred to as "the Willie Townes game." Townes was one of the first black athletes to play at The University of Tulsa. The bowl game marked his return to Mississippi where he had been subjected to racism most of his life. Twilley says Townes "was very motivated."

"There was one sequence where TU had taken the lead and Mississippi was trying to catch up," Jones recalls. "[Jim Weatherley] went back to pass on first down and Willie batted the ball out of the air. He went back to pass on second down and Willie batted the ball out of the air again. He went back to pass on third down and never got the ball away. Willie just buried him."

Tulsa won the game 14-7 and by the end of the year, Rhome had rewritten many of the NCAA passing records. He completed 198 passes without an interception while racking up 2,870 yards and 32 touchdowns. Rhome was voted Associated Press Back of the Year and he was Heisman Trophy runner-up. Twilley also had an outstanding year with 95 receptions for 1,178 yards and 12 touchdowns.

As Rhome left for the NFL and the Dallas Cowboys, Twilley still had a senior season left to play. He used it to break even more records with new starting quarterback Billy Guy Anderson. The 1965 campaign was much like the previous 9-2 season. Tulsa lost early games to number five Arkansas and Oklahoma State before reeling off seven consecutive victories. Twilley set the NCAA single game record with 36 points in the 51-18 blowout of Louisville. Anderson bested his old teammate Jerry Rhome by passing for 502 yards against Colorado State. The offensive tandem connected for an unscripted 89-yard touchdown play against Memphis State, the third longest in school history.

"We made up our own plays all the time," Twilley says. "We were supposed to run a curl pattern but I suggested that we change it into a curl and go. I was 15 yards behind [the defenders] when I caught it and I got hit on the goal line when I scored," Twilley says.

Tulsa was again invited to play in the Bluebonnet Bowl. This time they faced a stiff challenge in number seven Tennessee. Tulsa's offense never got on track and the Volunteers won, 27-6. The Golden Hurricane finished 8-3 and Twilley's amazing college career had ended. In his last

two seasons, Tulsa led the nation in total offense and passing offense. Like Rhome in 1964, Twilley was the 1965 Heisman Trophy runner-up and he received United Press International Lineman of the Year honors. To this day, he credits a Tulsa football legend for his success.

"For a whole number of guys that came through this door called The University of Tulsa's athletic program, Glenn Dobbs made a big difference with his life," Twilley says. "He taught us things that you need to learn like accountability and being on time and things that are important."

Dobbs continued to coach Tulsa for three more seasons. The Hurricane went 6-4 in 1966 and 7-3 in 1967 while claiming two more MVC titles. The 1967 squad upset number 10 Houston, 22-13. Dobbs' final year at the helm produced a disappointing 3-7 record, but nothing could diminish the achievements of his tenure. All told, Dobbs went 45-37 and coached five All-Americans and 46 All-MVC performers.

In 1969, TU struggled under new coach Vince Carillot. His 1-9 effort called for an immediate change that resulted in the hiring of Claude Gibson. He led Tulsa to a 6-4 record in 1970, but the Hurricane would lose 12 of its next 17 games. Things looked promising early into the 1971 season. Tulsa scored 21 unanswered points in the fourth quarter to defeat seventh-ranked Arkansas in Fayetteville. But midway through the 1972 campaign, Gibson's coaching stint had run its course.

At the time, former assistant coach F.A. Dry was serving as TU's athletic director. When Gibson was fired, Dry stepped in as head coach. He led Tulsa to a 3-2 record including a shocking 28-26 upset of number 17 Louisville. Dry quickly brought the Hurricane back to its winning form. In 1973, Tulsa went 6-5 and claimed the MVC championship. The 1974 team was loaded with future NFL talent including Steve Largent, Steve August, Al Humphrey and Jeb Blount. Tulsa finished 8-3 that year with a perfect 6-0 MVC record. The Hurricane also upset 15th-ranked Houston at Skelly Stadium. Tulsa finished at number 19 in the final UPI poll but was denied a bowl bid.

In 1975, a young Will Rogers High School graduate joined Tulsa's program in hopes of reliving the glory days of Jerry Rhome and Howard Twilley. David Rader grew up just two miles from the campus and sold programs at TU's home games.

"All throughout high school I played quarterback and I wanted to play quarterback in college," Rader says. "At that time, Tulsa was truly one of the few teams throwing the ball that much because most everybody was running the wishbone or the veer. For me, F.A. Dry being there was a big attraction."

As a freshman, Rader watched quarterback Jeb Blount lead Tulsa to a 7-4 record and a third consecutive MVC title. In 1976, Ron Hickerson took the reigns and guided the Hurricane to a 7-4-1 season. That year, the Hurricane defeated Virginia Tech 35-31 in Blacksburg. TU also pulled off an upset of 12th-ranked Arkansas on the strength of three Steve Cox field goals. Arkansas' kicker missed all but one of his five attempts and Tulsa escaped with a 9-3 victory. Ironically, Cox would later transfer to the same team he had single-handedly beaten.

Rader says that going into the Independence Bowl, the players "had a pretty good hunch" that F.A. Dry was leaving at the end of the season. "Before the game, he went around shaking all the players' hands," Rader says. "That was a pretty good clue. Rumors were rampant and a lot of his coaches were gone that whole week. The assumption was that they were recruiting for TCU."

Tulsa faced McNeese State in Shreveport, Louisiana, in a back-and-forth affair. With 4:22 remaining, Cox nailed a 38-yard field to put Tulsa in the lead, 16-14. All the Hurricane had to do was make a defensive stop. Instead, the Cowboys drove 80 yards and fullback Oliver Hadnot scored the 25-yard winning touchdown with just 37 seconds left in the game. Rader watched his team implode from the sidelines as a young sophomore quarterback. The next time Tulsa would play in a bowl game, it would return to Shreveport with Rader roaming the sidelines as the head coach.

In 1961, Glenn Dobbs returned to coach his alma mater and remained in that position through the 1968 season. He compiled a 45-37 record and led Tulsa to the Bluebonnet Bowl in both 1964 and 1965. In eight seasons, Dobbs coached 47 All-MVC players and five First or Second Team All-Americans. Dobbs also spent time as The University of Tulsa's Athletic Director. (The University of Tulsa.)

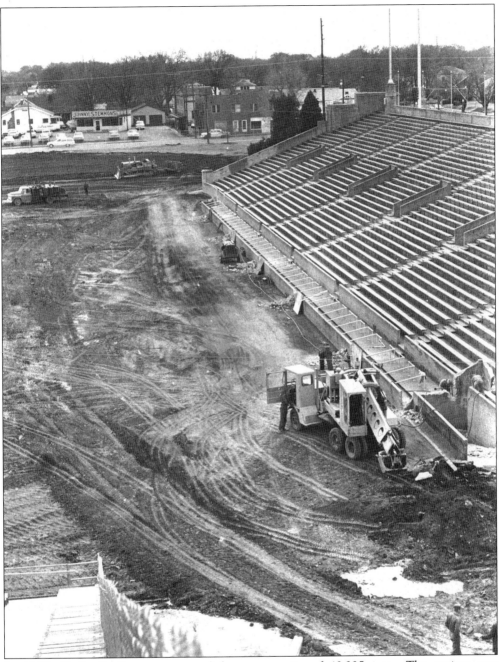

In 1965, Skelly Stadium was expanded to a capacity of 40,235 seats. The project cost $1,250,000 and included the removal of the track, the lowering of the field and the addition of box seats. A new two-story press box was also built. (The University of Tulsa.)

The 1964 team broke an 11-year bowl game drought with its 14-7 Bluebonnet Bowl victory against Mississippi. Under the direction of head coach Glenn Dobbs and assistant coach F.A. Dry, TU changed the face of the college football passing game. In doing so, the 1964 team led the nation in total offense with 461.8 yards per game and passing offense with 317.9 yards per

game. Tulsa finished the season 9-2 with other key victories coming against Houston, Louisville and Oklahoma State. The Golden Hurricane set 27 NCAA team and individual records and seven players received All-America honors. The 1964 team was inducted into TU's Athletic Hall of Fame in 2003. (The University of Tulsa.)

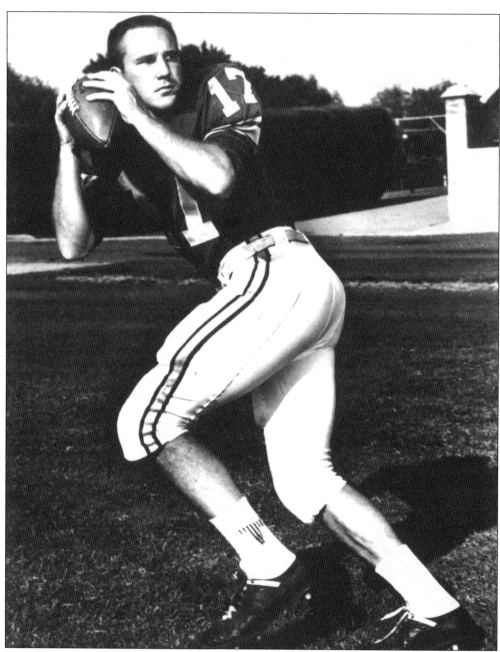

Jerry Rhome transferred from SMU in 1962. After sitting out a year, he spent his junior and senior seasons rewriting many of the NCAA passing records. Rhome threw for 4,779 yards and 42 touchdowns in his career. He was an All-American as a senior and finished second in Heisman Trophy voting. That season, Rhome led the nation in passing yardage and pass efficiency. He completed 198 passes without throwing an interception. Rhome played for the Dallas Cowboys and most recently has served as an assistant coach for several NFL teams. His number 17 jersey has been retired and in 1984, he was inducted into TU's Athletic Hall of Fame. In 1992, Rhome became The University of Tulsa's fourth member of the College Football Hall of Fame. (The University of Tulsa.)

50

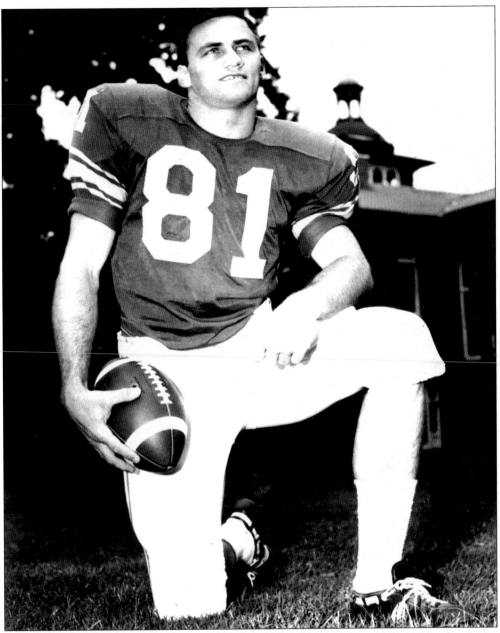

Howard Twilley played for Tulsa from 1963 to 1965 and became one of the greatest receivers in college football history. He still holds the record most career receptions in three years with 261. Twilley's 1965 mark of 13.4 receptions per game mark is also the best in NCAA history. He was the nation's leading receiver in both 1964 (1,178 yards) and 1965 (1,779 yards). In 1965, Twilley was also the NCAA scoring champion with 127 points. As a senior, he earned First Team All-America honors and was the Heisman Trophy runner-up. Twilley maintained a long NFL career with the Miami Dolphins where he played in three Super Bowls. His number 81 jersey has been retired and in 1984, he was inducted into TU's Athletic Hall of Fame. Twilley became Tulsa's third member of the College Football Hall of Fame in 1992. (The University of Tulsa.)

The 1965 team continued to solidify The University of Tulsa as one of the great passing school's in college football history. TU again led the nation in total offense with 427.8 yards per game and was the national passing champion with 346.4 yards per game. The Golden

Hurricane went 8-3 including 4-0 in Missouri Valley Conference play. Tulsa participated in its second consecutive Bluebonnet Bowl and suffered a 27-6 defeat at the hands of seventh-ranked Tennessee. (The University of Tulsa.)

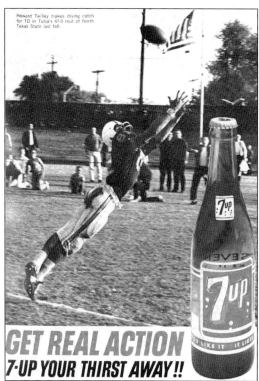

Howard Twilley makes diving catch for TD in Tulsa's 47-0 rout of North Texas State last fall.

GET REAL ACTION
7-UP YOUR THIRST AWAY!!

Pictured is a 7-Up advertisement from the October 23, 1965 TU vs. Cincinnati game program. Howard Twilley is shown diving for a reception in the 47-0 rout of North Texas State that took place November 14, 1964. (The University of Tulsa.)

Billy Guy Anderson drops back to pass during TU's 27-6 loss to Tennessee in the 1965 Bluebonnet Bowl. Anderson was Jerry Rhome's backup in 1963 and 1964 before emerging in 1965 to become one of the most prolific passers in school history. He led the nation in total offense (3,343 yards) and passing (3,464 yards) that year and his 502-yard passing effort against Colorado State ranks first in TU history. He was an 11th round AFL draft pick of the Houston Oilers and a 19th-round NFL draft pick of the Los Angeles Rams. Anderson, a Second Team All-America selection, was inducted in TU's Athletic Hall of Fame in 1986. His number 14 jersey was retired in 1995. (The University of Tulsa.)

Willie Townes makes a lunging tackle in TU's 14-0 victory at Houston on September 11, 1965. Townes was a dominant defensive lineman from 1964 to 1965. (The University of Tulsa.)

Twice named to the All-MVC team, Willie Townes was also honored as the MVC Sophomore of the Year in 1964. His memorable performance in the 1964 Bluebonnet Bowl earned him the title Outstanding Lineman. Townes was an All-America honorable mention that season. In 1966, he was selected as the second round draft pick of the Dallas Cowboys. (The University of Tulsa.)

Neal Sweeney was one of TU's great receivers from 1965 to 1966. In two seasons, he caught 134 passes for 1,623 yards. In 1965, he was a First Team All-MVC selection and All-America honorable mention. The Denver Broncos drafted him in 1967 where he had a brief NFL career. (Denver Broncos/The University of Tulsa.)

Rick Eber (left) played at TU in 1966 and 1967 while Harry Wood (right) played from 1966 to 1968. On October 7, 1967, against Idaho State, the receiving tandem set the NCAA record for most yards gained by two players on the same team in the same game. Eber totaled 322 yards while Wood added 318 yards. The two players combined for 640 yards and six touchdowns on 33 receptions. Wood's career tally of 138 receptions for 2,154 yards ranks eighth on TU's all-time receiving chart while Eber ranks ninth with 119 receptions for 1,902 yards. Eber was drafted in the sixth round of the 1968 NFL draft by Atlanta. (The University of Tulsa.)

Pictured is TU's 1968 freshman team that included a young Phil McGraw (top row, fifth from left) better known as TV's popular talk show host Dr. Phil. He left the team after injuries to the knee, and ironically, his head, ended his football career. Also on that team was future star receiver Jim Butler (top row, fourth from right). Butler led TU in receiving from 1969 to 1971 with 124 receptions for 1,322 yards and nine touchdowns. (The University of Tulsa.)

Josh Ashton played running back for TU from 1969 to 1970. He led the team in rushing both seasons for a combined 1,536 yards and earned All-MVC honors as a senior. In 1971, Ashton was the ninth round NFL draft selection of the Boston Patriots. (The University of Tulsa.)

Ralph McGill was a starting defensive back for Tulsa in 1970 and 1971. He was also the team's leading kickoff and punt return man. McGill's 97-yard punt return for a touchdown against Idaho in 1970 ranks as the longest in school history. That same year, he returned a Wichita State punt for an 86-yard touchdown. In 1971, McGill received Second Team All-America honors from the National Enterprises Association. The San Francisco 49ers selected him in the second round of the 1972 NFL draft. (The University of Tulsa.)

Claude Gibson coached the Golden Hurricane from 1970 to 1972 and compiled an 11-16 record before being replaced midway through the 1972 season. Gibson's crowning achievement came in 1971 when Tulsa upset seventh-ranked Arkansas, 21-20, in Fayetteville. (The University of Tulsa.)

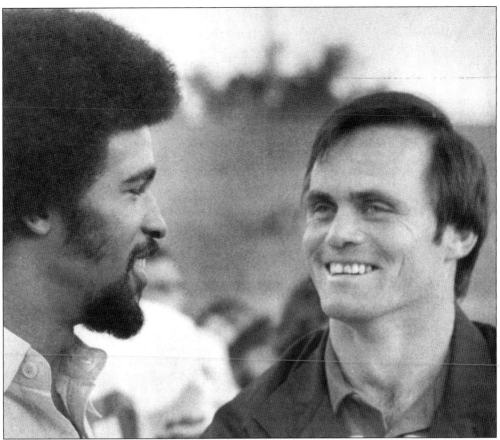

Drew Pearson chats with fellow TU alum and NFL receiver Howard Twilley. Pearson played for Tulsa from 1970 to 1972. He joined the Golden Hurricane as a quarterback but left having caught 55 passes for 1,119 yards. In 1973, Pearson signed with the Dallas Cowboys as a free agent where he played his entire NFL career. His career totals included 489 receptions and 7,822 receiving yards. Pearson played in three Pro Bowls and three Super Bowls. He was named to the NFL's 1970's All-Decade Team and in 1985, he was inducted into TU's Athletic Hall of Fame. (The University of Tulsa.)

Drane Scrivener played defensive back for TU from 1970 to 1972. As a senior, he was an All-MVC selection and received First Team All-America honors from the National Enterprise Association. In 1973, the Dallas Cowboys selected Scrivener with their fourth round pick of the NFL draft. (The University of Tulsa.)

Ray Rhodes played running back for Tulsa in 1972 and 1973. He ran the ball 171 times for 729 yards and a career average of 4.3 yards per carry. Rhodes was also an adept receiver and tallied 43 catches for 558 yards and five touchdowns. In 1973, he led TU with 19 kickoff returns for 501 yards, a school record that stood for 20 years. The New York Giants selected Rhodes in the 10th round of the 1974 NFL draft. He went on to a successful pro coaching career including a stint as the head coach of the Philadelphia Eagles. (The University of Tulsa.)

F.A. Dry took over as Tulsa's head coach midway through the 1972 season and continued through the 1976 campaign. He had previously served as an assistant to Glenn Dobbs. Dry led TU to four consecutive winning seasons and four consecutive MVC titles. During that time, Tulsa defeated number 17 Louisville 28-26 (1972), number 15 Houston 30-14 (1974) and number 12 Arkansas 9-3 (1976). In his final season, the Golden Hurricane went 7-4-1 including a 20-16 Independence Bowl loss against McNeese State. (The University of Tulsa.)

Al Humphrey played linebacker for TU from 1972 to 1974. He received All-MVC honors as a junior and senior and he was an Associated Press Third Team All-America selection. In 1975, the Pittsburgh Steelers drafted Humphrey in the eighth round of the NFL draft. His son Ryan is an NBA athlete with the Memphis Grizzlies. (The University of Tulsa.)

The 1974 team won the Missouri Valley Conference title by going 6-0 including victories against Louisville and New Mexico State. Coach F.A. Dry led the team to an overall record of 8-3. Tulsa closed out the season with an upset of 15th-ranked Houston (30-14). The Golden

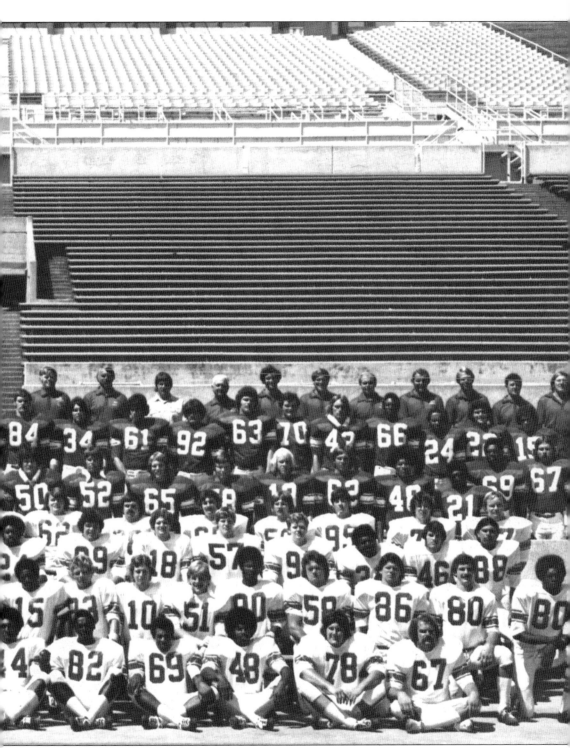

Hurricane was ranked 19th in the final United Press International poll. Steve Largent, Al Humphrey, Steve August and Jeb Blount were among the future NFL players on that team. (The University of Tulsa.)

Jeb Blount played quarterback for Tulsa from 1972 to 1975. He completed 54 percent of his passes while throwing for 4,343 yards and 35 touchdowns. Blount's 125.2 passing efficiency rating is fifth best among all TU quarterbacks. He was twice selected as an All-MVC performer. Blount joined the Oakland Raiders in 1976 as the team's second round draft pick. (The University of Tulsa.)

Steve Largent played receiver for TU from 1973 to 1975. As a junior and senior, he led the nation in touchdown receptions with 14 each season. Largent was twice named to the All-MVC team. His 2,385 career receiving yards ranks sixth on Tulsa's all-time chart. He is tied for second in all-time scoring among non-kickers with 192 points (32 touchdowns). Largent was inducted into TU's Athletic Hall of Fame in 1991. (The University of Tulsa.)

After a stellar college career, Steve Largent made a bigger name for himself in the NFL with the Seattle Seahawks. The Houston Oilers selected Largent in the fourth round of the 1976 draft but later cut him from the team. Former TU quarterback Jerry Rhome was instrumental in bringing him to Seattle where he stayed for his entire 14-year career. By the time he retired, Largent had set six NFL receiving records and made it to the Pro Bowl seven times. He later enjoyed a successful run as a member of the United States House of Representatives. In 1995, Largent was inducted into the Pro Football Hall of Fame. (Seattle Seahawks/The University of Tulsa.)

Steve August was a stalwart of TU's offensive line from 1972 to 1973 and 1975 to 1976. He was a three-year starter and earned First Team All-MVC honors and Third Team All-America honors as a senior. August was a first-round draft pick of the Seattle Seahawks where he played on the same team with TU teammate Steve Largent. He ended his career with the Pittsburgh Steelers. August was named to TU's Athletic Hall of Fame in 2001. (Seattle Seahawks/The University of Tulsa.)

The 1976 team was the first Tulsa team to go to a bowl game since 1965. In his final season as head coach, F.A. Dry led TU to the Independence Bowl where the team lost 20-16 to McNeese State. Notable players from that team included Dave Rader, Bill Blankenship, Steve August,

Rickey Watts, Cornell Webster and Jim Stewart who became the first TU player to return a kickoff 100 yards for a touchdown. He managed that feat in Tulsa's 35-31 win over Virginia Tech in Blacksburg. (The University of Tulsa.)

Cornell Webster played wide receiver for Tulsa in 1975 and 1976. As a senior, he led TU with 622 yards on 38 receptions. Webster's biggest game was against Oklahoma State when he caught seven passes for 105 yards in the losing effort. He was an All-MVC selection in 1976. Webster went on to have a successful NFL career spending most of his time with the Seattle Seahawks where he joined fellow TU alumni Steve August and Steve Largent. (Seattle Seahawks/The University of Tulsa.)

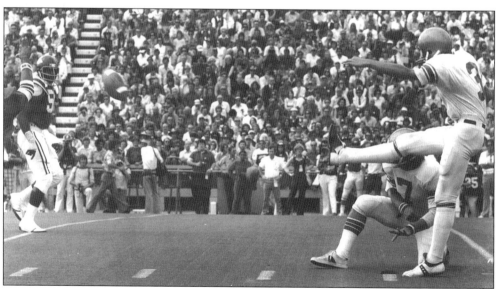

Steve Cox hits one of his three field goals in Tulsa's 9-3 victory over 12th-ranked Arkansas. Cox spent two years with the Golden Hurricane from 1976 to 1977 before transferring to play for Arkansas. (The University of Tulsa.)

FOUR

Cooper's Town
1977–1987

When F.A. Dry left Tulsa for TCU, he created another sizable hole much like the ones left by other great TU coaches such as Glenn Dobbs, J.O. Brothers, Henry Frnka, Elmer Henderson, Francis Schmidt and Sam McBirney. Enter a young first-year head coach named John Cooper. His resume' was impressive with assistant coaching jobs at Iowa State, Oregon State, UCLA, Kansas and Kentucky. But the average fan knew little about him. For Cooper, the feeling was mutual.

"I didn't know a lot about The University of Tulsa," Cooper says. "Obviously I'd heard of Howard Twilley and Steve Largent and Glenn Dobbs and those great passing teams they had. When I got that job, I was at the point in my coaching career where I wanted to be a head coach. I went and interviewed pretty much cold turkey. Nobody knew me and I didn't know anything about Tulsa."

During the 1977 season, Cooper spent most of the time ironing out his coaching system and getting to know the players and the university. The result was a 3-8 record and the last losing campaign a Cooper-led team would endure. Tulsa's dramatic improvement in 1978 earned them the title of the nation's Most Improved Team. David Rader was entering his senior season and as starting quarterback was surrounded by some serious talent. Rickey Watts led the offense with his ability to run, catch and return punts and kickoffs.

"I don't how Tulsa landed Rickey Watts," Rader jokes. "Rickey is still one of the best athletes I've ever been around. He did so many things well."

Against West Texas State, Rader was the statistical beneficiary of Watts' athleticism. He threw a 10-yard pass to his receiver and watched him record the fifth longest touchdown pass in TU history.

"Rickey made the corner miss then he made the safety miss," Rader says. "The corner fell down and got back up to tackle him again and Rickey made him miss again. Then he outran everybody else for an 81-yard touchdown."

Tulsa went 9-2 in 1978 but a Missouri upset of Nebraska allowed the Tigers to take a bowl bid that some had predicted would go to the Golden Hurricane. Over the next three seasons, Cooper's team continued to win. The 1979 squad went 6-5 with victories against Air Force, Kansas State and an impressive 20-10 defeat of Florida in Gainesville. Against Florida, Tulsa jumped out to a 10-0 lead before the Gators could respond with a touchdown.

"The crowd came alive and got into the ball game," Cooper says. "When they kicked off, they made a mistake. Instead of kicking the ball deep to our return guys, they kicked it to a freshman by the name of Ken Lacy and Lacy put the ball in the end zone."

In 1980, Tulsa improved to 8-3 and captured key wins over Kansas State, TCU and Cincinnati. Cooper also won his first of five consecutive MVC titles. The 1981 team went 7-4 with defeats of Kansas State and a loss to Kansas that the Jayhawks later forfeited due to the use of an ineligible player.

The 1982 team was loaded with the deadly combination of power and speed. The famed "Palomino Express" consisting of Michael Gunter and Ken Lacy became one of only two rushing tandems to run for over 1,000 yards each. Gunter led the team with 1,464 yards and a

NCAA best 7.5 yards per carry. Lacy wasn't far behind with 1,097 yards of his own. Tulsa had 11 players on the All-MVC team including offensive tackle Sid Abramowitz, defensive anchors Cliff Abbott and Kevin Lilly as well as one of the greatest kickers in TU history Stu Crum.

Tulsa opened with a dominant 35-17 victory against Air Force. The team suffered a 38-0 loss at the hands of number 13 Arkansas in Fayetteville, but bounced back by winning its last nine games. Included in that impressive streak was a 25-15 victory over Jimmy Johnson and the Oklahoma State Cowboys. TU also traveled to Lawrence and defeated Kansas 20-15. But at the end of the year, bowl officials snubbed the 10-1 Golden Hurricane.

"The thing that disappointed me is that we beat two teams, Air Force and Kansas, that went to bowl games," Cooper says. "We should have definitely been in a bowl game. We were better than a lot of people playing in a bowl."

In 1983, TU fans were introduced to a young quarterback from Claremore. Steve Gage brought with him an energy that permeated the entire team. While he hoped that Cooper and assistant Larry Coker would bring back the passing game he had grown up admiring, Gage soon realized that the option-styled offense suited him just as well.

"Once I got in it as a quarterback, it was fun because I had a little bit of speed so I could outrun some guys," Gage says. "I was involved in almost every play. It was literally an option to run, pass, hand the ball off or pitch it. So it's a lot of fun for a quarterback."

Gage opened the season as the starting quarterback and made quite a statement by scoring a 49-yard touchdown on his first career rushing attempt and tossing a 10-yard touchdown on his first career passing attempt. Tulsa went on to defeat San Diego State 34-9, but Gage has even stronger memories of his experience playing against eighth-ranked Oklahoma in Norman. The Sooners were loaded that year with star players such as Danny Bradley, Buster Rhymes, Marcus Dupree, Ricky Bryan and Scott Case. Gage says that Tulsa went into the game "fired up, ready to play." But OU's commanding 28-0 halftime was a confidence killer.

"We came in the locker room at halftime," Gage recalls. "It was pretty quiet. We felt like we were going to get chewed out by Coach Cooper. Everybody's waiting around and the seniors were pretty upset. Cooper finally came in and he says, 'okay guys, they're just better than us so just go out there in the second half and don't get hurt.' Then he turns around and walks out of the dressing room. We had a good group of seniors that year and they started to get ticked off. I think it was reverse psychology and we came out of the locker room jacked up."

"They played their starters a little bit and then they started to take their pads off," Gage continues. "Back then, Switzer would let his starters take their shoulder pads off and just stand on the sidelines. We scored a touchdown then we started playing pretty good. They didn't score and Switzer put those pads back on those guys and put them back in the game. We scored again and our defense was playing lights out. We got into the fourth quarter and we scored again. It should have been 28-21 but Cooper kept going for two points every time and we missed all of them."

Later in the season, Tulsa traveled to Lubbock, Texas, for a game against Texas Tech. In one of the most explosive offensive displays of the Cooper era, the Golden Hurricane ran roughshod on the Red Raiders. Bobby Booker ran the ball eight times for just 46 yards but led Tulsa with four touchdowns.

"We flew down there the morning of the game," Cooper says. "We got a meeting room at the Holiday Inn and met with our players a little bit, ate a pre-game meal and then went out and beat them, 59-20. We gave the players a box of Kentucky Fried Chicken and flew home."

In 1984, Tulsa went 6-5 and wrapped up another MVC title. As Cooper was preparing for spring practice, Arizona State contacted him about its head coaching vacancy. He had already turned down offers from Kansas, Iowa State, Memphis State, North Carolina State, Tulane and Texas Tech. Cooper finally gave in to one of its suitors and left Tulsa after seven consecutive winning seasons, five MVC titles and an overall 57-31 record. He would later move on to coach at Ohio State. Cooper, who still resides in Columbus, Ohio, is the only person to lead both a Pac-10 school and a Big 10 school to Rose Bowl titles.

"I was happy at Tulsa," Cooper says. "I wasn't looking to leave there. I could still be coaching at Tulsa. My career was great. The eight years that I spent at Tulsa were eight of the happiest years of my life."

Cooper had a major impact on the careers of his many talented assistants. Lovie Smith, Larry Coker, Bill Young, Steve Logan, Kurt Doll, Bob Babich, Denver Johnson, Don Blackmon, Alex Phillips and Bob Barry all went on to have successful careers of their own. Several of Cooper's players went on to play in the NFL and he has always contended that the talent he had at TU was of the highest quality.

"I made these people at Ohio State mad when I first came in here because I said we had better players when I coached at Tulsa," Cooper says. "I had some players at Tulsa that could've played on any of the great teams that I coached at Arizona State or Ohio State."

When Don Morton took over as TU's head coach, he inherited a healthy football program thanks to John Cooper's hard work. He also inherited some talented players in the middle of their careers. Steve Gage was entering his junior year and was determined to win back his starting job that he had lost to Richie Stevenson due to injury. By the opening game, Gage had accomplished his mission and Stevenson was eventually moved to free safety.

That season was the best statistical year of Gage's career. He scored 17 touchdowns, second in the nation only to Michigan State's Lorenzo White. In the 42-26 victory against Wichita State, he and running back Gordon Brown became the first modern rushing duo to gain over 200 yards in the same game. Tulsa finished 6-5 that year and claimed another MVC title. At the end of the season, the conference disbanded its affiliation with NCAA Division 1-A football. Some argue that Tulsa's dominance in the 70s and 80s ultimately led to the Missouri Valley's demise.

In 1986, Tulsa went 7-4 in its first season as an independent school. The Golden Hurricane defeated a Thurman Thomas-led Oklahoma State team 27-23 and gave number one-ranked Miami all it could handle in a close 23-10 contest on the road. Gage again found himself in the NCAA record books. Against New Mexico, he became only the second player in NCAA history to rush for 200 yards and pass for 200 yards in the same game.

"They played a lot of man coverage and we did a lot of sprint outs," Gage says. "A lot of times, the corners ran off and I got outside. If the throw wasn't there, I'd run for twenty or thirty yards. They didn't have a clue on how to stop the option. We had a field day."

As Gage ended his career, Coach Morton was also leaving Tulsa after two seasons and a combined 13-9 record. He departed to take over as head coach at Wisconsin. George Henshaw was Morton's replacement and for the 1987 season, he asked former TU quarterback David Rader to join his staff. At the time, Rader was recruiting southern Mississippi for his job at Mississippi State.

"I thought, 'if I'm going to drive around here lost, I might as well go back to Oklahoma where I at least know the roads,'" Rader recalls. "I did it because of my love for the school and my love for my family. In a professional sense, I was defensive coordinator at a SEC school at age 29. You shouldn't leave that job."

Under Henshaw, Tulsa sputtered to a 3-8 record. The Golden Hurricane found itself on the wrong end of lopsided contests against Florida, Central Michigan, Texas Tech and top-ranked Oklahoma. By the end of the season, Henshaw was looking for ways to get out of his contract so he could take a position with the Denver Broncos. Rader was surprised and had no idea of Henshaw's intentions. All of the assistant coaches were nervous about the likelihood that they would be looking for new jobs soon.

"Nobody wanted to have another coach come in and have to move again or go find another job," Rader says. "So we said, 'who among us has the best chance to land this?' And they said, 'you do David.' And I said, 'well, I don't want to be braggadocios but I think you're right.'"

The loyal alum found himself sitting in a position he had never dreamed of filling, but for Rader there was no better fit.

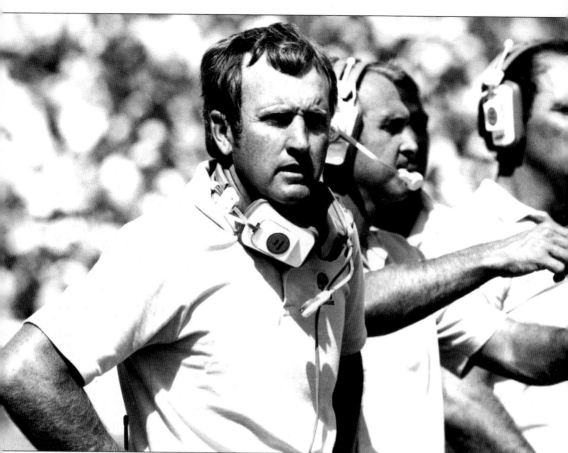

John Cooper took the reigns of Tulsa's football program in 1977. After opening his career with a 3-8 record, he led the Golden Hurricane to seven consecutive winning seasons including the 1982 team that went 10-1. After his final season in 1984, Cooper moved on to Arizona State and then Ohio State where he made history by becoming the only head coach to win Rose Bowl championships with teams from both the Pac-10 and Big 10. (The University of Tulsa.)

Future head coach Dave Rader played quarterback for Tulsa from 1975 to 1978. As a senior he led TU with 90 completions for 1,683 yards and 14 touchdowns. Rader holds the school record for fewest career interceptions with just nine in the 20 games he played. His 81-yard touchdown pass to Rickey Watts in 1978 against West Texas State ranks as the fifth longest in school history. Rader's 126.9 career passing efficiency is the fourth best among TU quarterbacks and his 1978 rating of 142.8 ranks third best. In 1979, the San Diego Chargers selected him with its 11th-round pick. (The University of Tulsa.)

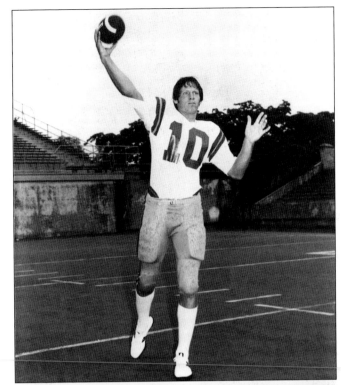

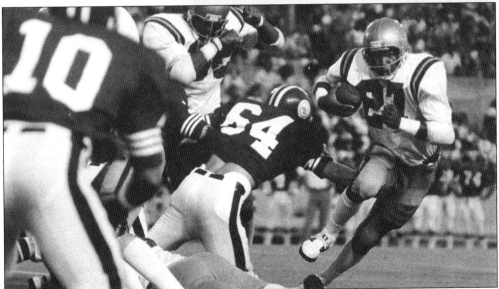

Rickey Watts played tailback and receiver for TU from 1976 to 1978. As a sophomore, he led the team in rushing with 464 yards on 99 carries. In 1977, Watts was led the team in rushing, receiving and punt return yardage. During his senior season, he had his best year as a receiver leading TU with 34 catches for 730 yards and five touchdowns. He also paced all Tulsa players with nine kickoff returns for 224 yards. Watts was an All-MVC performer that year and went on to play professionally with the Chicago Bears as the second round pick of the 1979 NFL draft. (The University of Tulsa.)

Bill Blankenship eludes defenders in a home game against Wichita State. He played quarterback for Tulsa from 1976 to 1979. Blankenship led TU in passing as a sophomore with 1,293 yards on 93 completions. As a senior, he split the duties with Kenny Jackson, but still led the team with 627 yards on 38 completions. Blankenship went on to a successful career as a high school football coach. He has repeatedly led Tulsa's Union High School to the 6A State Championship game. (The University of Tulsa.)

Lovie Smith played safety for TU from 1976 to 1979. He was named MVC Newcomer of the Year in 1976 and followed that honor by earning three First Team All-MVC awards. As a junior, Smith was named a Second Team All-American. After his playing career, he went into coaching where he served as an assistant at his alma mater under John Cooper. Smith eventually moved into the NFL coaching ranks where he had a successful tenure as the defensive coordinator for the St. Louis Rams. Most recently he was named the head coach of the Chicago Bears. Smith was named to TU's Athletic Hall of Fame in 1999. (The University of Tulsa.)

Don Blackmon was one of the best defensive ends in TU history. He played for the Golden Hurricane from 1977 to 1980. His 336 career tackles ranks fourth among all Tulsa players. Blackmon set a school record with 40 tackles for 239 lost yards. He was named All-MVC three years and as a senior received the MVC Defensive Player of the Year award. The Associated Press named Blackmon a Second Team All-America selection in both 1979 and 1980. He went on to have a successful career in the NFL as New England's fourth round pick of the 1981 draft. Blackmon was inducted into TU's Athletic Hall of Fame in 1989. (New England Patriots/The University of Tulsa.)

Kenny Jackson played quarterback for TU from 1978 to 1981. As a junior, he led the team with 1,208 yards passing and eight touchdowns. For his career, he completed 176 passes for 2,506 yards and ran for 826 yards and 18 touchdowns. Jackson was a Second Team All-MVC selection in 1980. His career 120.2 passing efficiency rating ranks sixth among all TU quarterbacks. (The University of Tulsa.)

Stu Crum was a kicker for Tulsa from 1978 to 1980. He sat out the 1981 season due to injury then returned as a senior in 1982. Crum ranks second on TU's all-time scoring chart with 266 points. His mark of 49 career field goals is fourth best in school history. Crum has kicked six of TU's 15 longest field goals including the two longest, a 58-yard kick against Southern Illinois in 1980 and a 57-yard kick against Oklahoma State in 1982. The New York Jets selected him with its 12th-round pick of the 1983 draft. (The University of Tulsa.)

Sid Abramowitz played offensive tackle for Tulsa from 1979 to 1982. He was All-MVC as a junior and as a senior. Abramowitz anchored the offensive line for the 1982 team that went 10-1 under the direction of Head Coach John Cooper. The Baltimore Colts selected him with its fifth-round pick of the 1983 draft. (The University of Tulsa.)

Ken Lacy played tailback for Tulsa from 1979 to 1982. He teamed with Michael Gunter to become one of only two college duos to rush for over 1,000 yards each in a single season. As a senior, he rushed for 1,097 yards, the seventh best effort by a TU back. He gained 2,272 yards and scored 20 touchdowns throughout his career. Lacy ranks fifth on Tulsa's all-time rushing chart. He was twice named an All-MVC performer and played professionally with the USFL's Michigan Panthers. Lacy was named to TU's Athletic Hall of Fame in 1998. (The University of Tulsa.)

Michael Gunter played tailback for Tulsa from 1980 to 1983. Along with Michael Gunter, he made up the other half of the famed "Palomino Express." Gunter ended his career as TU's all-time leading rusher with 3,536 yards, 32 touchdowns and an average of 6.2 yards per carry. As a junior, he set the school's single-season rushing record with 1,464 yards. His average of 7.5 yards per carry led the NCAA. Gunter was a First-Team All-MVC selection in both 1982 and 1983. As a senior, he was named the MVC's Offensive Player of the Year. Tampa Bay selected Gunter with its fourth-round pick of the 1984 draft. He was inducted into TU's Athletic Hall of Fame in 1996. (The University of Tulsa.)

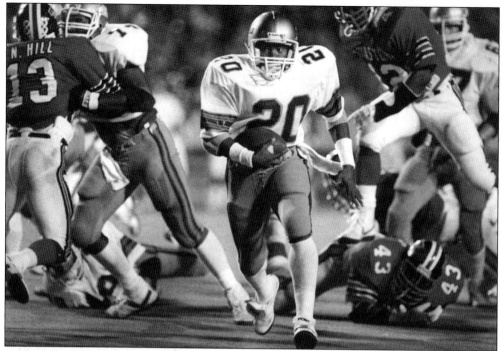

On October 22, 1983, Bobby Booker gained only 46 yards on eight carries against the Texas Tech. However, four of those carries resulted in touchdowns as Tulsa routed the Red Raiders 59-20 in Lubbock. Booker played running back for TU from 1981 to 1985. His younger brother was former Oklahoma State and NFL receiver Hart Lee Dykes. (The University of Tulsa.)

Nate Harris played defensive back for the Golden Hurricane from 1981 to 1984. In 1984, he set the school's single season interception record with eight. He and Jeff Jordan share the school record for career interceptions with 13. Harris went on to play professionally with the USFL's Denver Gold. (The University of Tulsa.)

Jason Staurovsky went from team manager to starting kicker overnight. He played for TU in 1981 as a replacement for the injured Stu Crum then returned to kick for Tulsa from 1983 to 1985. Staurovsky ended his career as the school's all-time leader in field goals (53) and scoring (281 points). His longest field goal was a 56-yard boot against Southern Illinois in 1984. Staurovsky eventually found a home in the NFL as a free agent with the New England Patriots. (The University of Tulsa.)

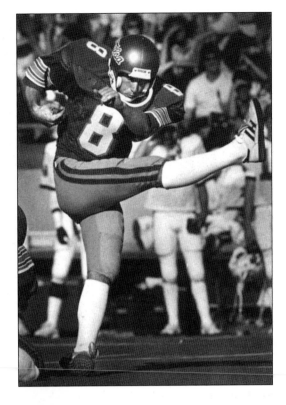

Gordon Brown played running back for Tulsa in 1984 and 1985. After transferring from Hutchinson Junior College, he was named the MVC Newcomer of the Year. His 214-yard performance against Wichita State in 1985 ranks ninth in TU history. As a senior, Brown carried the ball 169 times for 1,201 yards, Tulsa's fourth best single-season mark. In just two seasons, he rushed for 2,196 yards, sixth highest among TU backs. (The University of Tulsa.)

Steve Gage played quarterback for Tulsa from 1983 to 1986. As a true freshman, both his first rushing and passing attempts resulted in a touchdown. Gage was named MVC Newcomer of the Year that season. He and Gordon Brown became the first teammates in NCAA history to each rush for 200 yards in the same game. Gage was also the second player in NCAA history to rush for 200 yards and pass for 200 yards in the same game. During the 1985 season, he was second in the nation in scoring (102 points) behind Michigan State's Lorenzo White. His brief NFL career included stints with the Super Bowl champion Washington Redskins and the Miami Dolphins. Gage was inducted into TU's Athletic Hall of Fame in 2000. (The University of Tulsa.)

Xavier Warren played linebacker for Tulsa from 1983 to 1986 although a broken arm kept him from any action during the 1985 season. Warren was a First Team All-MVC selection in 1984 with 132 tackles and three sacks. He ended his career as the ninth leading tackler at TU with 283. (The University of Tulsa.)

Tim Gordon played defensive back for Tulsa 1983 to 1986. He was a three-year starter and tallied 146 career tackles. Gordon also returned 43 punts for 461 yards and one touchdown. He went on to have a successful NFL career as a free agent pickup of the Atlanta Falcons. (The University of Tulsa.)

David Alexander was a four-year letterwinner and three-year starter for TU from 1982 to 1986. He spent time at both the offensive tackle and guard positions earning First Team All-MVC honors in 1984 and 1985. Alexander was also named an honorable mention All-American as a junior and senior. He went on to a lengthy NFL career with the Philadelphia Eagles and the New York Jets. Alexander was inducted into TU's Athletic Hall of Fame in 2003. (The University of Tulsa.)

Don Morton was TU's head coach in 1985 and 1986. He compiled a 13-9 record and led Tulsa to its final MVC title as the conference disbanded its football division at the end of the season. Morton had his best season in 1986 as TU went 7-4, including a 27-23 defeat of Oklahoma State. He left after two seasons to take the top job at Wisconsin. (The University of Tulsa.)

Steve Gage and Eric Brown celebrate in the end zone after Brown scored the winning touchdown against Long Beach State on October 12, 1985. A year later, the two players would connect for a 78-yard touchdown play against Tennessee Tech, the 10th longest in school history. (The University of Tulsa.)

In 1987, George Henshaw coached Tulsa to a 3-8 record. TU's lone bright spots came in the form of road wins against Kansas State and Temple as well as a home defeat of Louisville. The top-ranked Oklahoma Sooners invaded Skelly Stadium that season and handed Tulsa its worst home loss in school history (65-0). At the end of the season, he left the program to take an assistant coaching position with the Denver Broncos. (The University of Tulsa.)

Derrick Ellison carries the ball against the Florida Gators. He played running back for Tulsa from 1985 to 1988. Ellison's team-leading 1,064 rushing yards in 1986 stands as the ninth best single-season mark in TU history. He finished his career with TU's 11th-best rushing total with 1,864 yards. (The University of Tulsa.)

FIVE

Peaks and Valleys

1988–2002

David Rader's first season as head coach was a slight improvement from a year before. The team went 4-7 and notched victories against Kansas State, UNLV and Colorado State. In 1989, several football independents formed a bowl coalition that was aligned with the struggling Independence Bowl. Tulsa joined with Memphis State, Louisville, SW Louisiana, Louisiana Tech and Cincinnati to compete for a post-season berth.

Tulsa opened with wins over UTEP and a 20-10 victory over Oklahoma State. After a 26-7 loss to ninth-ranked Arkansas, TU returned to Skelly Stadium for a game against New Mexico. A strange extenuating circumstance would play a part in the end result. One of the goal posts was leaning severely and everyone noticed.

"I remember going out on the field in pre-game and seeing that and thinking 'oh my goodness, this makes us look so bad that we can't even get the goal post straight,'" Rader recalls. "What are you going to do? You're not going to jump up and hang on the one end and hope it rotates. You just think it's not going to matter anyway. But Murphy of Murphy's Law was all over that. Lo and behold if they don't line up to kick to beat us and they hit the upright that's leaning."

Tulsa's 35-33 victory preserved a shot at the bowl bid. The Hurricane had an up-and-down season, but by the end of the year, a 6-5 record was good enough for a trip to Shreveport. But as the team prepared for its game against Oregon, Tulsa's All-American receiver Dan Bitson was involved in a horrific car accident right around the corner from Skelly Stadium and the football offices. While the wreck was not Bitson's fault, he suffered the brunt of the collision and would spend the next few days fighting for his life.

As Bitson's condition stabilized, TU faced the daunting task of playing without him. He had just come off a career year with 73 receptions for 1,425 yards and 16 touchdowns, the third best receiving performance in TU history. The *Associated Press* had already named Bitson a Second Team All-American.

Tulsa faced Oregon, the PAC-10's second place team, and entered the game as 16-point underdogs. But the Hurricane was determined to give the big conference school a run for its money. By halftime, TU had taken a 17-10 lead. Herbert Harvey's blocked punt resulted in a 21-yard touchdown return. Tulsa seemingly took control with a third quarter touchdown run by Brett Adams and the 24-10 lead. Oregon fought back with two touchdowns to tie the game in the fourth quarter. On a controversial play, an apparent Oregon fumble was overruled and the Ducks retained possession. On that same drive, they kicked a 20-yard field goal to win the game 27-24.

In 1990, key injuries and bizarre situations kept the Hurricane off its game. The team went 3-8 but still managed to make a little history. Against New Mexico State, backup tailback Mark Brus was called into duty replacing injured starter Brett Adams. Tulsa's game plan was simple that day. Run the ball, run the ball again, and then run the ball some more. Brus obliterated TU's record books that day with 43 carries for 312 yards. He also scored three touchdowns.

As the 1991 season approached, the fans and the media had many questions and few answers regarding TU's outlook. According to former Tulsa Tribune sports writer Ken MacLeod, there

was nothing spectacular to report during pre-season workouts. T.J. Rubley was back from his knee injury and Dan Bitson was attempting to make a comeback, but otherwise, everything seemed relatively normal.

"They weren't anymore optimistic in preseason that year than they were any year," MacLeod says. "There was always optimism and lot of times you're blowing smoke. Sometimes the coaches may know something you don't know but I don't think anybody knew how good that Chris Penn was going to be or how good Chris Hughley was going to be. Nobody knew that there were seven guys that were going to have long NFL careers walking on the field."

Tulsa started the season with consecutive victories over SW Missouri State and Oklahoma State. After a tough loss at Kansas, TU was staring at two straight home games against nationally ranked opponents. The first team to emerge from the visiting team's locker room was #15-ranked Texas A&M. To no one's surprise, Tulsa found itself trailing 28-10 at halftime. Quarterback Jeff Granger and tailback Greg Hill were having a jolly good time. TU's players were not amused.

"There was a good feeling of confidence," Rader says. "I'd like to say it was a great halftime speech but the only thing I said to them was, 'guys they're a good football team, but they're not eighteen points better than us. Let's put our game together and let's go win it.' I couldn't even finish the sentence because guys were running me over to run back on the field."

Rader opines that TU's third quarter against the Aggies, "may have been the best quarter of football in TU history." Tulsa scored 19 points and took its first lead of the game. A&M battled back to reclaim that lead, but with 3:54 left in the game, Rubley and junior college transfer Chris Penn connected for one of the most memorable plays to ever unfold at Skelly Stadium.

"TJ made a nice throw and put it right over the guy's fingertips," Rader says. "As the play was going on, I was hollering at Coach [Rocky] Felker in the headset saying, 'can he out run him Rocky, can he out run him?' And Coach Felker said, 'he can out run him, he can out run him!' And he out ran him. Is there a better moment at Skelly Stadium?"

The 63-yard touchdown play secured the 35-34 upset, but not to be overlooked, it was the consistent play-breaking ability of Chris Hughley that kept TU in the game. "Chris Hughley went nuts that day," Rader says. "In pre-game warm ups, the A&M (defensive backs) were calling out Chris. Chris turned to his teammates and said, 'are they talking to me?' And his teammates said, 'yeah, they're talking to you.' 231 yards later, he answered."

A week later, Tulsa gave a valiant effort in its 34-10 loss to second-ranked Miami. The Golden Hurricane then reeled off six consecutive wins en route to the Freedom Bowl. But along the way, TU still needed some major breaks to keep its hopes alive. Against Southern Mississippi, Tulsa avoided a 10-10 tie as Rubley's Hail Mary pass to Penn set up a game-winning field goal attempt by Eric Lange. As a snowstorm blanketed the stadium, Lange slipped on the icy field and missed the 32-yarder. According to Rader, there was a blatant holding penalty that wasn't called on the play but the back judge did throw a flag on the Eagles who had 12 men on the field. Lange was given a second chance and with no time remaining, he drilled his second kick for the 13-10 victory.

While Penn was making big plays throughout the season, Dan Bitson was contributing in other ways. His presence on the team was inspirational, even though his reconstructed legs weren't able to perform to the level of his All-American days. Late in the season against Ohio, Bitson brought the crowd to its feet with his first touchdown catch in two years.

"It was bittersweet," MacLeod says. "It was great to see him do it but he was a shadow of his former self. He worked so hard to get back. Nobody's ever worked as hard as Dan did to get back on the football field. Just to see him playing was great. He was a splendid athlete, just one of the best receivers I'd ever seen in college football. You talk about the pro guys that had great careers after that '91 team, Dan's would have been the best of any of them."

After a close call against SMU, the 9-2 Golden Hurricane prepared to face San Diego State at the Freedom Bowl in Anaheim, Calif. Like the bowl game two years earlier, the team would go without one of its star players. This time, it was leading rusher Chris Hughley who remained

home due to academic suspension. Rader says it was "probably the toughest coaching decision I ever made as a head coach."

"What people don't know is that we had a team meeting before the game," Rader says. "It was at that time that we knew we would win. I walked out of our team meeting with every bit of confidence that the Golden Hurricane would win. It was one of those special moments that come along so few times. When we walked out of that meeting, San Diego State had no chance."

The Aztecs were led by future NFL star Marshall Faulk. Experts expected him to have another big game. In fact, San Diego State only managed to rush for 189 yards and Faulk was outplayed by TU's backup tailback Ron Jackson. Tulsa's offensive line was led by All-American Jerry Ostroski and stalwart center Todd McGuire. They opened massive holes for Jackson who had a career day with 211 yards on 46 carries. He also scored all four of TU's touchdowns and was named Freedom Bowl MVP as the Golden Hurricane emerged with the 28-17 victory.

TU finished the season 10-2 and was voted the number 21 team in the nation. From that squad, seven would go on to play in the NFL, including Tracy Scroggins, Barry Minter, Gus Frerotte, Fallon Wacasey, Ostroski, Rubley and Penn. Tulsa was also the nation's most improved team having increased its win total by six and a half games.

"I'm very biased," Rader says, "but I think it was the best team the program has ever had."

On the heels of the Freedom Bowl year, The University of Tulsa under the direction of President Robert H. Donaldson decided to drop the Health, Physical Education and Recreation (HPER) program from the curriculum. It was publicized as an attempt to raise the university's academic standards. Many athletes traditionally have sought a HPER degree en route to a career in coaching.

"When we cancelled that program, we were still required to play Oklahoma, we were still required to play Iowa, we were still required to play Oklahoma State," Rader says. "We still had to play A&M some more. We got into the WAC where we played Utah, Brigham Young and Colorado State. There were some requirements that were really tough. The young men with whom I had the pleasure of working did a great job fighting that battle."

MacLeod covered the story and recalls Rader's concern was there from the beginning. "I didn't realize what kind of impact it was going to have but I think you have to take his word," MacLeod says. "All the way through his career at TU, he always pointed to that as the one thing that really tied his coaching staff's hands behind their backs. They tried to mitigate it with the exercise science program but it wasn't the same as being able to go out and recruit five or six really good junior college athletes to plug the gaps. Take the [junior college players] off the 1991 team and they would have been a five hundred team."

The next eight seasons under Rader proved to be difficult times for TU's football program. From 1992 to 1995, Tulsa went 15-28-1. Rader led the team to back-to-back victories against Houston in '92 and '93. Other key wins during that time came in 1994 against Missouri and 1995 against Oklahoma State.

In 1993, Edison High School graduate Wes Caswell joined the Golden Hurricane. Two injuries would stretch his career over a rare six-year period of time. His most memorable year came in 1996 when TU first joined the Western Athletic Conference. After opening with losses to SMU and Oklahoma State, Tulsa pulled off one of its most impressive feats in recent history.

It all started when 19th-ranked Iowa visited Skelly Stadium. The Hawkeyes boasted one of the nation's best pass defenses and they were stacked with future NFL players including tailback Tavian Banks. When told by coaches that they would have trouble passing the ball, TU's receivers took exception and exploded to help Tulsa to a 27-20 upset.

Tulsa then traveled to Norman to meet the Oklahoma Sooners. Quarterback John Fitzgerald had been injured late in the game against Iowa and left the door open for Troy DeGar to reclaim the starting role he once enjoyed. The game had gone back and forth and Oklahoma looked to take control as they neared TU's goal line. Safety Jeremy Bunch forced Demond Parker to fumble the ball on a leaping touchdown attempt giving Tulsa the ball at its own one-yard line. After a run up the middle for no gain, offensive coordinator Mark Thomas called for a passing

play. The players were so surprised, they asked to have the call signaled twice to make sure.

"They were in an all-out blitz," Caswell says. "I made [the cornerback] miss and Joe Montana couldn't have thrown a better pass. Troy was a great quarterback before he hurt his knee. Afterwards, he wasn't the best drop back passer. He was more of roll out guy. For him to throw that ball like he did was unbelievable."

Muadianvita Kazadi, who had torn his bicep muscle in the Oklahoma State game, secured the 31-24 victory with by snagging an interception with one arm, essentially ended the contest. TU followed that win with a 20-14 defeat of heavily favored WAC opponent Colorado State. The Golden Hurricane struggled down the stretch and finished 4-7 overall—but not without those spectacular moments.

"What always impressed me about Rader was that when he had a big time opponent coming in to play, he could come up with some of the most brilliant game plans," MacLeod says. "Conversely, there were a lot of times I thought they were playing teams that equal to or had less talent than TU and the game plans were pretty vanilla. Maybe his one failing as a coach was that if he thought he could beat you by being conservative, then he'd play it that way. If he knew he had to pull out all the stops, he did it and it was brilliant."

In 1999, Rader was relieved of his duties as head coach with four games remaining on the schedule. Assistant coach Pat Henderson was named interim coach during that time. Tulsa finished the season 2-9. According to Tulsa World sports writer Jimmie Tramel, Rader was finding it more difficult each year to convince recruits that the program could be restored to its former glory.

"I don't think coach Rader did anything but fight his guts out to turn it around," Tramel says. "You could tell on his face that he was fighting it the whole time. He looked pretty worn out by the time he was finished and he looked a lot better after the fact. I never thought David Rader was guilty of malpractice."

Rader took some time away from coaching before he moved to Alabama in 2003 and took the job as offensive coordinator and quarterbacks coach. Even after the abrupt ending to his career at TU, he still speaks fondly of his years spent there. "The University of Tulsa job to me was not a job," Rader says. "I was paid a salary but we were there because Tulsa is a special place to me. Even though we didn't have everything, we had good people."

In 2000, TU introduced Keith Burns as its new head coach. He had built a solid resume with high profile assistant coaching jobs at Arkansas and USC, among others. Burns was energetic and ready to take on the challenge of winning football games at The University of Tulsa. That first year looked promising as he led TU to a 5-7 mark and a 4-4 WAC record. Tulsa defeated Hawaii, Rice, Louisiana Tech and San Jose State.

From the sidelines, a young redshirt quarterback named James Kilian watched the season unfold. Going into the 2001 campaign, he says the team was making plans to win the WAC Championship. Instead, the Golden Hurricane would endure one of its worst losing streaks and a quarterback controversy that would split the team in half.

In 2001, most anticipated that Tulsa Union product Josh Blankenship would retain his starting position. But in the third game of the season at UTEP, he was benched in favor of freshman and fellow Union alum Tyler Gooch. MacLeod doesn't claim to know the details of what happened during that game, but he says there were apparently hard feelings on both sides.

"One of the strangest things was what happened with [Burns] and the quarterback situation," MacLeod says. "After his second year when he benched Blankenship, in the press conferences he would never talk about Josh. I thought to myself, 'boy that's kind of weird.' Here's a guy that's on pace to potentially become the leading passer in TU history and it sounded like something was brewing."

Kilian eventually moved up to second on the depth chart. It was an awkward situation thanks to his close friendship with Blankenship. As the team continued to lose, the team unity quickly deteriorated.

"I would say that we had some what of a split on the team," Kilian says. "I think there was

some undermining of the leadership of the upperclassmen. They felt like they had their hands tied at times. It almost wasn't their team. That division in our team just killed us. With the quarterback controversy all season, we just couldn't get any continuity on offense. From week to week, we didn't know what we were going to do."

At the end of the 2001 season, Tulsa was strapped with a 1-10 record and Blankenship announced he was transferring. TU entered 2002 season with no quarterback controversy, but the wounds from the previous year's problems hadn't completely healed. Tulsa opened the season with #1-ranked Oklahoma at Skelly Stadium. By halftime, the Sooners were only winning 3-0 and the imaginations of TU's fans were working overtime. Oklahoma pulled away in the second half for the 37-0 victory.

TU's losing streak continued and reached a NCAA-worst 17 consecutive games before a frustrated Hurricane team unloaded on UTEP for a 20-0 Homecoming victory. "It was just a tremendous relief," Kilian says. "At that time, I didn't realize how tough it was to win in college. When we lost that many in a row it was like, 'man, can we not just get one win?' We finally did and it was a big burden off our chest."

By the end of the year, rumors ran rampant of an impending coaching change. TU's limping program was now on life support having gone 2-21 over two years. Kilian and his teammates weren't surprised, although no one really knew what was going to happen.

"From my standpoint, a coaching change was needed," Kilian admits. "I was looking forward to getting a fresh start."

Dennis Byrd played defensive tackle for Tulsa from 1985 to 1988. He finished his career as the seventh-leading tackler in school history with 321 total tackles. Byrd also set the school record for quarterback sacks with 20. In 1989, the New York Jets selected him with its second round draft pick. His career was cut short by a freak playing accident that left him paralyzed from the neck down. Byrd's miraculous recovery was chronicled in the inspirational autobiography *Rise and Walk*. The book was also made into a TV movie. (The University of Tulsa.)

David Fuess was Tulsa's kicker from 1986 to 1989. As a senior, he set a school record with five field goals in the 30-22 loss at Iowa. Fuess is second on TU's all-time field goal chart with 51 and fourth on TU's all-time scoring chart with 250 points. (The University of Tulsa.)

Brett Adams played tailback for Tulsa from 1987 to 1990. He led TU in rushing yardage in 1988 (602) and 1989 (1,071). The latter total ranks eighth on the all-time single season rushing chart and his career mark of 2,121 yards is the eighth best in school history. (The University of Tulsa.)

Mark Brus played tailback for Tulsa in 1989 and 1990. He tallied career marks of 1,022 rushing yards and five touchdowns. Brus set TU single-game rushing records with 312 yards and 43 attempts against New Mexico State in 1990. He was a 1989 All-America Collegiate Scholar and 1990 District VI Academic All-American. (The University of Tulsa.)

Dan Bitson played split end for Tulsa from 1987 to 1990. Along with Howard Twilley, he is considered one of the top two receivers to play for the Golden Hurricane. Bitson was a Second Team All-America selection in 1988 and 1989 with consecutive 1,000-yard receiving performances (1,138 and 1,425). A near-fatal car accident after the 1989 season kept Bitson out of the Independence Bowl. He made an astounding comeback and finished his career in 1991 by catching nine passes for 129 yards and a touchdown. Bitson finished second on TU's all-time receiving chart with 3,300 yards and 29 touchdowns. (The University of Tulsa.)

92

Todd Hays played linebacker for Tulsa from 1990 to 1991. As a senior, he tallied 74 total tackles and two sacks for minus 23 yards. He also recovered three fumbles. Hays served as a one of the team captains throughout TU's 10-2 season. He won a silver medal at the 2002 Winter Olympics in the bobsled event. (The University of Tulsa.)

T.J. Rubley played quarterback for Tulsa from 1987 to 1991. After suffering a season-ending knee injury against Arkansas in 1990, he received a medical hardship and finished out his career by leading TU to a 10-2 season and Freedom Bowl championship. Rubley finished his career as the school's all-time leader in passing (9,324 yards), total offense (9,080 yards) and touchdown passes (73). He was the 15th player in NCAA history to surpass the 9,000-yard barrier. The Los Angeles Rams selected Rubley with its ninth-round pick of the 1992 draft. He also played with Denver and Green Bay and was NFL Europe's league MVP when he played with the Rhein Fire. (The University of Tulsa.)

Barry Minter played linebacker for TU from 1989 to 1992. He earned four letters and was a two-year starter. His 267 career tackles is just five shy of Tulsa's all-time chart. Minter collected 11 tackles for 54 lost yards and six career sacks for 63 lost yards. He snagged six interceptions including one that resulted in a 48-yard touchdown during his junior season. Dallas drafted Minter with its sixth round pick of the 1993 draft. The Cowboys traded him to Chicago where he enjoyed a successful career. (The University of Tulsa.)

Jerry Ostroski played offensive guard for Tulsa from 1987 to 1991. As a senior, he earned First Team All-America honors from the Associated Press, Football Writer's Association of America and The Sporting News. Ostroski is considered to be one of the best linemen in school history. Kansas City selected him with its 10th-round pick of the 1992 draft. He landed with the Buffalo Bills where he eventually won a starting role. Ostroski later played a role in TU's hiring of head coach Steve Kragthorpe. (The University of Tulsa.)

Michael White was a four-year starting linebacker for Tulsa from 1988 to 1991. He finished his career as the school's all-time leader in total tackles (389) and unassisted tackles (227). As a senior, White tallied 16 tackles against Southern Mississippi and registered 13 stops in key wins against Oklahoma State, Texas A&M and Ohio. (The University of Tulsa.)

Chris Penn played wide receiver for TU in 1991 and 1993. He made some of the biggest catches in TU history during the 1991 season including the game-winning touchdown against Texas A&M and the Hail Mary reception (pictured here) that set up the winning field goal against Southern Mississippi. In 1993, Penn led the NCAA with 9.6 receptions per game and 143.5 yards per game. He finished his career in seventh place on TU's all-time receiving chart with 2,370 yards. As a senior, Penn was a Second Team All-America selection. Kansas City selected him with its third round pick of the 1994 draft. (The University of Tulsa.)

Eric Lange was TU's kicker from 1991 to 1992. His second-chance field goal against Southern Mississippi gave Tulsa a 13-10 victory and kept its bowl chances alive. Lange ranks fifth on Tulsa's all-time field goals chart with 35. (The University of Tulsa.)

Tracy Scroggins played linebacker for Tulsa in 1990 and 1991. As a senior, he was third on the team with 88 tackles. In two years, he compiled 138 tackles, 10 tackles for loss (minus 30 yards), 10 sacks for minus 73 yards and three fumble recoveries. The Detroit Lions selected Scroggins with its second round pick of the 1992 draft. (The University of Tulsa.)

Ron Jackson played tailback for Tulsa from 1989 to 1992. He earned the 1991 Freedom Bowl MVP trophy after rushing for 211 yards and four touchdowns. Jackson finished his career with a total of 1,859 yards and six touchdowns. (The University of Tulsa.)

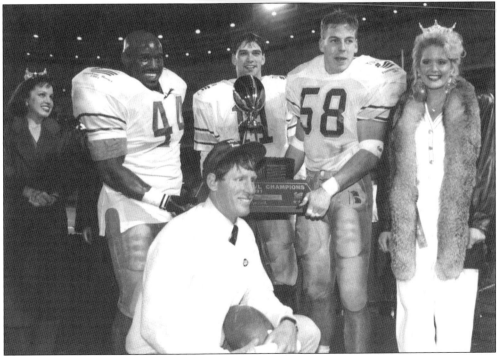

From left to right, 1991 team captains Michael White, T.J. Rubley and Todd Hays along with head coach David Rader (kneeling) pose with the Freedom Bowl trophy after defeating San Diego State 28-17. The 10-2 Golden Hurricane finished the season ranked number 21 in the final Associated Press rankings. (The University of Tulsa.)

Gus Frerotte played quarterback for TU from 1990 to 1993. As a senior, he recorded Tulsa's second-best single-season passing performance with 2,871 yards. Frerotte ranks third on TU's all-time passing chart (5,480 yards) and total offense (5,553 yards). The Washington Redskins selected Frerotte with its seventh round pick in the 1994 draft. He has also played with Detroit, Denver, Cincinnati and Minnesota. (The University of Tulsa.)

Sedric Clark played defensive end for Tulsa from 1992 to 1995. He earned honorable mention All-America honors from the Football News. Clark tied Dennis Byrd's all-time sack record with 20 and set a new mark for sack yardage with minus 152. For his career, Clark totaled 204 tackles including 119 unassisted stops. The Oakland Raiders selected him in the 1996 NFL draft. (The University of Tulsa.)

David Millwee played offensive center for TU from 1992 to 1995. He was named to the 1995 Hitachi/CFA Scholar Athlete Team and was one of 17 scholar athlete award winners as named by the National Football Foundation. Millwee earned *Football News* All-America honors in 1994. (The University of Tulsa.)

Salifu Abudulhai played defensive end for Tulsa from 1993 to 1996. As a senior, he was named First Team All-WAC Mountain Division. He set the school's single-season record for quarterback sacks (12) and sack yardage (76). Abudulhai finished his career with 139 total tackles and 18 quarterback sacks and 139 sack yards. (The University of Tulsa.)

Muadiavita Kazadi earned four letters and started three years at linebacker from 1993 to 1996. As a senior, he led all TU tacklers with 130 stops and was named Second Team All-WAC Mountain Division. He ranks sixth on Tulsa's all-time tackles list with 328. St. Louis selected Kazadi with its sixth round pick of the 1997 draft. (The University of Tulsa.)

Solomon White played tailback for Tulsa from 1993 to 1996. In 1994, he recorded the longest rushing play in TU history when he sprinted 93 yards for a touchdown against UNLV. White's 265-yard performance ranks second among TU's best in a single game. White is the fourth-leading career rusher in TU history with 2,553 yards. With 25 career touchdowns, only Michael Gunter (32) and Steve Gage (30) have scored more times on the ground. (The University of Tulsa.)

Troy DeGar played quarterback for Tulsa from 1993 to 1996. After earning his first start as a sophomore against Missouri, a knee injury early in the first quarter ended his season. DeGar started all 11 games in 1995 and he completed 120 passes for 1,304 yards and six touchdowns. As a senior, he led Tulsa to a 31-24 defeat of Oklahoma with his record-setting 99-yard touchdown pass to Wes Caswell. DeGar concluded his career with 209 completions for 2,686 yards and as the only post-40's TU quarterback to start in victories over both Oklahoma and Oklahoma State. (The University of Tulsa.)

Jason Jacoby played running back for TU from 1994 to 1997. He set several kickoff return records including most returns in a season (35), most career returns (117), most return yards in a game (183), most return yards in a season (798) and most career return yards (2,572). As a freshman, he returned a kickoff against UNLV for a 100-yard touchdown. He duplicated the feat a year later against BYU. (The University of Tulsa.)

Pictured is Wes Caswell just after catching a pass from Troy DeGar in a 1996 game against Oklahoma. Caswell raced 99 yards for the record setting touchdown play. Tulsa went on to defeat the Sooners 31-24. Caswell finished his career in fourth place on TU's all-time receiving chart with 196 receptions for 2,562 yards. He earned Second Team All-WAC Mountain Division honors in both 1998 and 1996. (The University of Tulsa.)

John Fitzgerald played quarterback for Tulsa from 1994 to 1998. As a junior, he completed 54 percent of his passes (139 of 256) for 2,003 yards and nine touchdowns. He finished second on TU's all-time passing chart with 5,822 yards. He also finished second on Tulsa's all-time total offense chart with 6,258 yards. He has had a successful Arena Football League career playing for Dallas and New Orleans. (The University of Tulsa.)

Damon Savage played wide receiver for Tulsa from 1996 to 1999. He had his best season in 1997 with 66 receptions for 1,084 yards and six touchdowns. The Holland Hall product ranks third on TU's all-time receiving chart with 2,952 yards and 16 touchdowns. His career total of 212 receptions is second only to Howard Twilley. (The University of Tulsa.)

Todd Franz played defensive back for TU from 1996 to 1999. He started 33 of 40 games throughout his career. Franz finished his career with 182 tackles including 133 unassisted, 35 pass breakups and five interceptions. He was a First Team All-WAC selection in 1999 and was a Second Team All-WAC Mountain Division performer in 1998. Detroit selected Franz with its fifth round pick of the 2000 draft. He has also played in the NFL with New Orleans, Cleveland, Green Bay and Washington. (The University of Tulsa.)

David Rader coached his alma mater from 1988 to 1999. He became the third coach in TU history to lead the Golden Hurricane to at least two bowl games in his career. Rader's best season was the 1991 team that went 10-2 and defeated San Diego State in the Freedom Bowl. Tulsa was ranked 21st in the nation. In 12 seasons, Rader compiled a 49-80-1 record. He has the third-most victories of any TU coach. Rader is pictured here with the 1989 Independence Bowl runner-up trophy and the 1991 Freedom Bowl championship trophy. (The University of Tulsa.)

Kevin Shaffer played on Tulsa's offensive line from 1998 to 2001. The Atlanta Falcons selected him as their seventh round pick of the 2002 draft. (The University of Tulsa.)

Josh Blankenship played quarterback for Tulsa from 1999 to 2001 before transferring to Murray State after his junior season. Blankenship left TU as the fourth-best passer in school history with 5,273 yards. In 2000, he recorded the fourth-best single-season passing performance with 2,507 yards. That same year, he completed 28 of 49 passes against Oklahoma State for 373 yards, the 10th-best single game output at Tulsa. (The University of Tulsa.)

Sam Rayburn earned four letters and started three years at defensive tackle for Tulsa from 1999 to 2002. He was named First Team All-WAC as a senior and honorable mention as a junior. Rayburn had 138 career tackles including a record-tying 40 for loss. In 2001, he set a new school mark with 17.5 tackles for loss. The Philadelphia Eagles signed him to a free agent contract in 2003. (The University of Tulsa.)

Keith Burns coached Tulsa from 2000 to 2002. After a promising 5-7 record in 2000, Burns failed to lead TU to more than one victory over the next two seasons going 1-10 in 2001 and 1-11 in 2002. He left Tulsa with a combined 7-28 record over three years. (The University of Tulsa.)

SIX

The Kragthorpe Era Begins

As TU's 2002 season was mercifully coming to an end, a young quarterback coach with the Buffalo Bills found himself at a crossroads. Steve Kragthorpe had reached most every football coach's dream by finding a home in the NFL. But midway through his second season at Buffalo, a personal revelation changed the course of his professional journey.

"I just woke up about the middle of last year," Kragthorpe says. "We were actually in Houston playing the Texans. I thought, 'this is crazy.' I've mortgaged my family for the National Football League. It's a thrill. You walk down that ramp on Sunday afternoon. There's nothing like it. It's incredible. The energy is just amazing. But while I was walking down that ramp for the game, my wife and three kids were walking down the aisle at church and I wasn't there because I was working every Sunday. I hadn't made a conscious decision to do it, but subconsciously I was sending the message to my kids and to my wife that football was more important to them and more important than going to church."

At the time, Kragthorpe didn't know how he would rectify the problem. He just knew he had to find a way to better balance his career with his family. That's when he met former TU All-American Jerry Ostroski and recently retired Bills offensive lineman. The team was in Kansas City to play the Chiefs when at the Saturday night team meal, Ostroski showed up to meet some former teammates and he introduced himself to Kragthorpe. Ostroski mentioned a possible opening at TU and Kragthorpe, a coach that earned his stripes in college football, was immediately intrigued.

On December 18, 2002, Kragthorpe was named the 26th football coach at The University of Tulsa. For many fans and members of the media, his hiring was somewhat unexpected. There were others on the list of candidates that had stronger ties to the program. Kragthorpe made an instant positive impact on his newly acquired players. James Kilian, a junior quarterback from Medford, Okla., had a good feeling about his new coach from the onset.

"My first impression was that this is a good guy," Kilian says. "He's going to be fair. He's going to give everybody an opportunity. It was refreshing for me to hear that he was led to be here. When you have a coach that feels that way, that really feels like this is the place they're supposed to be, I think good things usually follow."

That summer, the team went through one more significant change as starting quarterback Tyler Gooch opted for a transfer to the University of Oklahoma where he hoped to pursue a baseball career. The move came just weeks before two-a-day practices and completely surprised Kilian, but didn't change his attitude towards the position.

"Since I've been here, I've tried to have the mindset of a starter," Kilian says. "But certainly, as last year unfolded with the new coaching, I began to prepare myself even more that it was going to be my job. I was going to do whatever it took to be the starter. Of course, when Tyler left, it opened the door wide open. It was my job to lose then."

Having nothing to lose and plenty of confidence to gain, TU tackled the opening game against Minnesota with the attitude of playing to have fun. The Golden Hurricane put together a solid first drive but missed an early opportunity to score when Brad DeVault pushed a 31-yard

field goal attempt wide left. From that point, Minnesota's fleet-footed quarterback Asad Abdul-Khaliq wreaked havoc on Tulsa's young defensive unit and the Golden Hurricane found themselves down 35-0 at halftime.

With no chance of winning the game, Tulsa continued to battle and look for positives. One fourth-quarter play proved to be one of the most exciting of the year and gave a glimpse into the future. With a long fourth down looming, Kilian found himself under severe pressure from the Minnesota defense.

"I had the ball in my left hand just tucking it away," Kilian recalls. "There was nothing I could do with the ball. I didn't want to fumble. I was just going to take the sack. As I'm falling, I kind of see [Eric Richardson] on the sideline waving his hands out of the corner of my eye. I just switched it over to my right hand and flung it out to him. Most people had given up on the play on defense. E-Rich snuck out of the backfield and almost took it in for the touchdown."

Kilian converted that play into a one-yard score. He finished the game with 171 yards passing on 18 of 32 attempts. Late in the game, DeVault added a 30-yard field goal. Tulsa left the Metrodome with a 49-10 loss and a pretty good idea of how far the team still had to go in its quest for massive improvement.

There was little time for rest as Tulsa traveled a week later to Fayetteville for another installment of its long-standing rivalry with Arkansas. By most standards, the Razorbacks were even better than the team TU had faced one week earlier. However, after the first quarter, TU was only down 7-3 and showed signs up putting up a good fight. Unfortunately, penalties and the Hurricane's inability to get the ball into the end zone allowed Arkansas to score 21 unanswered points. The second half was a close affair, but TU still found itself on the losing end of a lopsided 45-13 contest.

"After the Arkansas game, we walked out of that stadium saying 'we can play with these guys,'" Kragthorpe says. "We felt like it was a much closer game than the score indicated. We felt like with three or four or five plays in that game we could've maybe flipped the loss. We walked out of that game as a team saying if we continue to progress as a team and continue to work hard and minimize some of these self-inflicted errors that we've made, we can be a pretty good football team and we can compete with anybody on our schedule. Even though we lost that game, I thought that was a little bit of a turning point for us."

Steve Kragthorpe addresses the media at a press conference announcing his hiring as TU's 26th head coach on December 18, 2002. He left his position as the quarterback coach with the Buffalo Bills to take the job. (The University of Tulsa.)

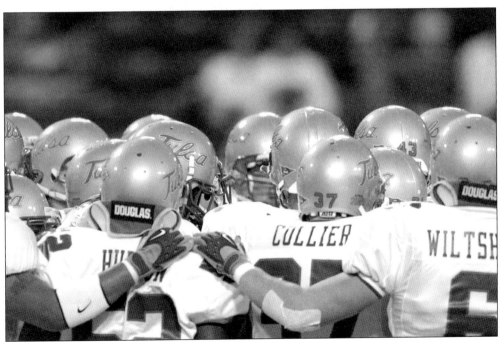

The Golden Hurricane huddles up in preparation for the first game of the 2003 season against Minnesota. (The University of Tulsa.)

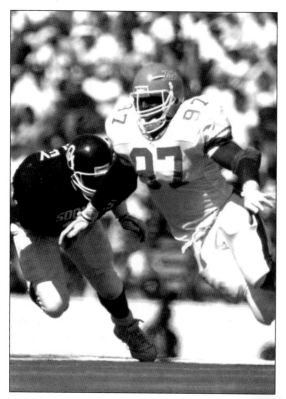

Senior Jeremy Davis and the TU defensive line attempt to block a Minnesota field goal. Davis finished his career at Tulsa as four-year letterwinner. He compiled 86 total tackles, 11.5 tackles for lost yardage and four sacks. Davis was an All-WAC honorable mention. (The University of Tulsa.)

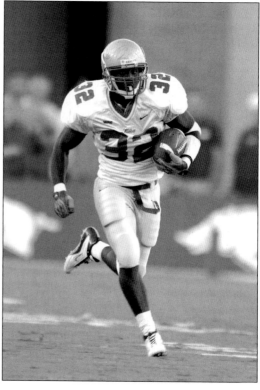

Senior linebacker Jorma Bailey runs for 38 yards on a fake punt against Arkansas. He finished the season third among all tacklers with 80 stops. Bailey led TU with 13.5 tackles for minus 91 yards. He also paced the team with seven sacks for minus 69 yards and seven quarterback hurries. (The University of Tulsa.)

SEVEN

Signs of Life

After losing two games to high caliber opponents, Tulsa was faced with the daunting challenge of opening at home against Texas State. In the minds of fans, the NCAA Division I-AA school was supposed to be a relatively easy victory, even for a Golden Hurricane team that had seen little success over the past two seasons. But Texas State was known as a haven for Division 1-A transfers that by most standards could compete at high levels.

TU struggled early and had to score a late second quarter TD to take a 7-3 halftime lead into the locker room. "We hadn't won a lot of games and we thought we had to win this one," Kilian says. "We felt a little pressure. At halftime, Coach Kragthorpe got on us a little bit. He told us to just go out there and play. In that third quarter, we just cut it loose and Coach Stubbs opened it up with some passing plays and we got rolling from there."

The Golden Hurricane stormed back onto the field with a vengeance. Kilian completed a 49-yard bomb to Montiese Culton on the first play of the second half and Eric Richardson scored a seven-yard TD on the next play to complete the 56-yard drive. TU's defense continued to contain the Bobcats' potent offense. Just eight minutes into the third quarter and Tulsa had scored three touchdowns opening up a 34-3 lead. Kilian led all rushers with 90 yards on 10 carries and a touchdown score. He also completed 15 of 24 passes for 244 yards and three TD passes. It would prove to be the Hurricane's strongest offensive outing of the season with 530 total yards including a dominant 273 yards on the ground. Texas State outscored the Hurricane 12-7 in the fourth quarter, but it wasn't nearly enough as TU won convincingly, 41-15

A week later, TU faced another opponent that fans hoped would provide a comfortable win. The Golden Hurricane knew better than to overlook an Arkansas State team that defeated TU, 21-19, a year earlier. The Indians had pressed Texas A&M in College Station and TU was still learning how to win ball games.

"We knew it was going to be tough," Kilian says. "We thought it was going to be a four-quarter game."

To the contrary, TU's defense dominated the game with three interceptions including a 12-yard touchdown return for true freshman Nick Bunting. The Indians scattered 271 yards of offense across four quarters, mostly on the ground, while Tulsa countered with a balanced attack that resulted in 404 total yards. Special teams also played a vital role as Jermaine Landrum returned a punt for 41-yard touchdown and Brad DeVault drilled field goals from 32 and 41 yards.

"Defense came out and stuffed them," Kilian says. "That was a big game for us. We were going into a bye week starting conference play. To go into that bye week sitting at 2-2 was big for us. We had a lot of confidence."

The bye week came at an opportune time for the Hurricane. The team had an extra week to prepare for the preseason WAC favorite Hawaii Warriors. More importantly, Tulsa's coaches were able to devise a defensive strategy to slow down quarterback Timmy Chang and Hawaii's explosive passing game. Coming into the game, the Warriors were ranked 12th nationally in total offense and 25th in scoring offense.

Early on, it looked as if Tulsa was shell-shocked. Hawaii jumped out to a 16-3 lead having scored on its first three possessions. Late in the second quarter, the momentum abruptly switched gears when Oliver Fletcher picked off Chang and TU subsequently drove 44 yards in four plays. The drive was capped by Kilian's 22-yard pass to Richard McQuillar.

The second half was a completely different story. Tulsa's defense dominated and the Kilian-led offense kept Hawaii on its heels with some clever play calling. For instance, in a rare twist, Kilian finished the game as TU's leading passer, rusher and receiver. He completed 12 of 26 passes for 106 yards, ran the ball 18 times for 115 yards and caught two passes (one from Jermaine Landrum, the other from Monroe Nichols) for 35 yards.

When Kilian wasn't shaking things up on the field, he was watching in awe from the sidelines as his defensive teammates did what most thought impossible.

"I see that odd stack in practice everyday," Kilian says. "It seems like they've got a million (defensive backs) out there. I saw a lot of confused looks on quarterbacks' faces. We just wore them down in the fourth quarter. I think that's when guys started to think we might have a special year."

Tulsa World sports writer Jimmie Tramel was likewise impressed with TU's ability to force Hawaii back on its heels.

Defensive coordinator "Todd Graham really did some nice thing to confuse Timmy Chang and get into his head a little bit," Tramel says. "Specifically, [Chang] would look down for the shotgun snap and by the time he got the ball, he would look up and the defenders were in different places then where they were before the ball was snapped. They really got into his head and he had a bad game."

Senior defensive end Jeremy Davis not only got into Chang's head, it seemed most of the day he was in his back pocket. Davis received WAC Defensive Player of the Week honors for his career day that included six tackles, three sacks for minus 19 yards and two hurries. Sophomore Kedrick Alexander led all defensive players with nine tackles while Bunting registered his second interception of the season.

TU received national recognition for its rags to riches victory. The team that was supposed to finish last in the WAC dominated the team that was picked to finish first. That feat garnered the CollegeSportsReport.com I-A Team of the Week award. Coach Kragthorpe and his team had suddenly thrust themselves into the middle of a conference race.

Jermaine Hope picks off a pass against Texas State. He tallied six tackles against the Bobcats and finished the season with 75 stops and three interceptions. Hope was a Second Team All-WAC selection. (The University of Tulsa.)

Montiese Culton advances the ball after snagging one of his two catches for 69 yards against Texas State. Culton caught 23 passes for the year and gained 416 yards, third best on the team. His longest play was a 54-yard touchdown reception against Arkansas State. (The University of Tulsa.)

James Kilian tucks and runs in the game against Hawaii. He completed a rare feat by leading the team in passing (106 yards), rushing (115 yards) and receiving (35 yards). (The University of Tulsa.)

Nick Bunting intercepts a pass to stop a Hawaii drive. He finished the season with 79 tackles, three sacks and a pair of interceptions. Bunting was named First Team All-WAC and WAC Freshman of the Year. (The University of Tulsa.)

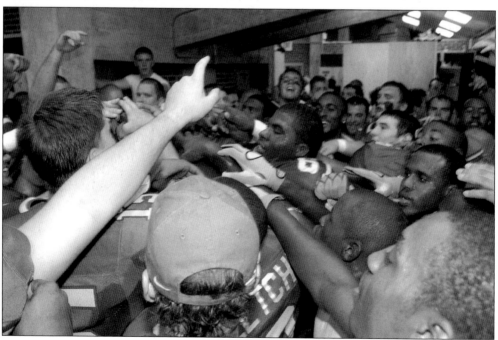

Tulsa celebrates in the locker room after upsetting Hawaii 27-16. The Warriors were the preseason pick to win the WAC while the Hurricane was expected to finish last. (The University of Tulsa.)

EIGHT

Character Builders

Tulsa's victory against Hawaii was a great confidence booster and spoke volumes of the program's lightning quick turnaround, but the team's next game would provide an even greater challenge. The Golden Hurricane traveled to Idaho for a contest with WAC powerhouse Boise State. Entering the game, the Broncos had only lost once at home in its past 30 games.

True to form, Boise State charged out of the gate with a pair of first-quarter field goals and two second-quarter touchdowns. Tulsa's offense was stifled and the Golden Hurricane never crossed the 50-yard line in eight possessions.

"It was sad that we came out as flat as we did on offense," Kilian says. "Coming off the big win against Hawaii, it was disappointing. We just couldn't get anything going. We missed some opportunities."

But in the second half, Tulsa showed their developing character with yet another strong finish. TU's defense tightened and Boise State's dangerous offense, led by Ryan Dinwiddie, found it difficult to move the ball on its own notorious blue turf. By game's end, Dinwiddie had only managed to complete 12 of 26 passes for 199 yards and no touchdowns. Conversely, Kilian heated up and finally got TU on the scoreboard with a 10-yard pass to Romby Bryant. Eric Richardson's 21-yard touchdown run moved TU to within six points.

Late in the fourth quarter, Boise State put together its best drive of the half, a 10-play, 68-yard affair that culminated in David Mikell's five-yard touchdown. With just 38 seconds remaining in the game and a 10-point deficit, TU made a frantic comeback attempt. On the first play from scrimmage, Kilian connected with Bryant who streaked down the sideline for the 80-yard score. That play tied for the seventh-longest passing play in TU history and was the longest since Jerry Keeling's 80-yard touchdown pass to Bobby McGoffin against Oklahoma State in 1960.

The ensuing extra point was no good, but TU was now only down 27-20. The Golden Hurricane attempted the onside kick but a Boise State player covered the ball and TU's hopes were dashed. Bryant finished the game with seven receptions for 148 yards and two touchdowns. Kilian outplayed his Boise State counterpart with 229 yards and two touchdowns on 22 of 35 passing. More impressively, TU showed that, despite the loss, they were apparently ready to hang with the WAC's big boys.

"Boise doesn't just beat people at home, they beat the heck out of people at home," Jimmie Tramel says. "You could almost say they run it up on people at home. For Tulsa to be within seven points against the team that is clearly the kingpin of the WAC provided more positive reinforcement that Tulsa could be competitive in the WAC."

TU returned to Skelly Stadium for another top-flight matchup. Nevada was another team expected to finish near the top of the WAC. The Wolfpack were fresh off an upset road victory against Washington and quarterback Andy Heiser brought another effective passing attack to the table. But it was the running game that caused TU the most problems.

Nevada jumped out to a 14-0 first quarter lead. Chance Kretschmer scored his first of two touchdowns on a two-yard run less than five minutes into the game. Kretschmer would finish with 171 yards on 31 carries. Tulsa countered with a strong showing by sophomore Uril Parrish.

His three-yard touchdown run in the second quarter got TU back into the contest. Parrish had a career day with 148 yards on 19 carries and all three of Tulsa's touchdowns. With less than a minute remaining in the first half, Nevada pulled a stunt from TU's playbook with a pass from Kretschmer to the quarterback Heiser. Tulsa faced a two-touchdown deficit at the break.

After a scoreless third quarter by both teams, TU got the ball moving in the fourth quarter, mostly on the ground. Nevada scored once more with just under six minutes left in the game to seal Tulsa's fate. But it wasn't defense that cost TU, rather it was an uncharacteristic fit of turnovers that doomed the Golden Hurricane. Tulsa came into the game ranked first nationally with only four turnovers. They gave up more than that in one game as Kilian had two of his passes picked off and TU lost three fumbles.

"We made too many costly errors in the football game, and those were tough to overcome," Kragthorpe says.

Tulsa dropped to 3-4 on the season and 1-2 in conference play. The defeat of Hawaii two weeks earlier almost seemed meaningless at this point. Kilian, ever the optimist, was himself bitten by a rare fit of regret having seen a major opportunity slip away.

"That was a disappointing loss for us," Kilian says. "We felt like if we lost to Boise but won out, maybe someone would knock of Boise and we'd get a share of the title."

Instead, the Golden Hurricane would have to fight through the disappointment and hope for even more help from its conference foes. A seemingly favorable schedule gave the team hope that it could still salvage a promising season.

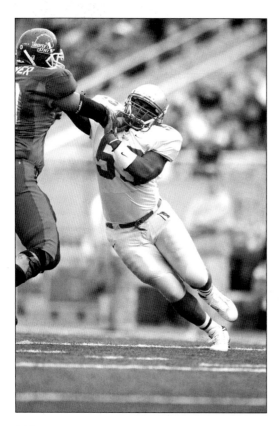

Senior Sammy Umobong battles to get past a Boise State offensive lineman. Umobong finished his career with 44 tackles and 2.5 sacks for minus 21 yards. (The University of Tulsa.)

Uril Parrish runs with the ball against Nevada. Parrish had a career day on the ground totaling 148 yards and three touchdowns in the losing effort. His season was cut short when he suffered a knee injury against UTEP. Parrish still managed to finish the year with 537 yards rushing and 5 touchdowns. (The University of Tulsa.)

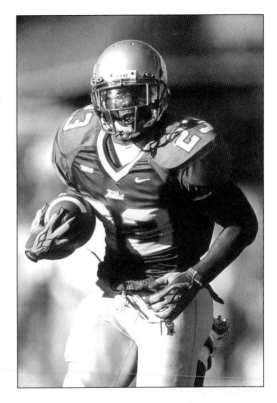

Brad DeVault watches his 52-yard field goal attempt miss its mark against Nevada. Despite the errant kick, DeVault made strides in 2003 with eight field goals on 15 attempts. Three of those kicks were from 40 to 49 yards away. DeVault led TU in scoring with 76 points. (The University of Tulsa.)

Michael LeDet drops into his defensive stance against Nevada. In his first season as a junior college transfer, LeDet finished second in total tackles with 91 at the linebacker position. He also tallied nine tackles for loss, four quarterback sacks and an interception. LeDet was named Second Team All-WAC. (The University of Tulsa.)

Senior Austin Chadwick anchors the offensive line against Nevada. The four-year letterwinner played in 47 career games and started 31 times at offensive tackle. Chadwick was named First Team All-WAC. (The University of Tulsa.)

NINE

On a Roll

After two tough losses, the Golden Hurricane faced the remainder of the schedule with renewed resolve. "There wasn't a guy on the team that didn't feel like we couldn't win five in a row," Kilian says. "We were excited about the next five games but we still had to take one game at a time. We really had to do that."

Tulsa began its quest at Skelly Stadium by facing the struggling SMU Mustangs on Homecoming. Few were shocked to see the visitors score the game's first points. Keylon Kincade ran for 11 yards on the scoring play and gave SMU the 7-0 lead. Tulsa bounced back with three unanswered touchdowns and two more to seal the 35-16 victory.

With a full head of steam, TU hit the road for an old-fashioned WAC shootout against the University of Texas at El Paso. After giving up the obligatory first quarter scoring drive, the Golden Hurricane responded with three first-half touchdowns. Tulsa's commanding halftime lead quickly dissipated thanks to a blocked punt that was returned for a touchdown and UTEP's following touchdown drive. The Golden Hurricane responded with two of its own scoring drives that resulted in both rushing and receiving touchdowns for junior tight end Caleb Blankenship.

After UTEP cut the lead to 35-28 just 36 seconds later, Kilian stepped up and took control of the fourth quarter. He ran for a 49-yard touchdown then led Tulsa on a methodical 11-play, 54-yard drive that resulted in his third rushing TD of the game. With just two minutes remaining, Brandon Diles scored the game's final touchdown on an exciting 20-yard run. Tulsa tallied 506 yards of total offense and scored its most points of the season in the 56-28 victory.

One week later and TU found itself back in Texas, this time for a meeting with the Rice Owls in Houston. After leading most of the game, Tulsa found itself trailing 28-24 with just 5:32 remaining in the game. Kilian marched his team down to Rice's 31-yard line. It was third and nine and less than a minute in the game. Tulsa ran a play called 62 Razor.

"The DB just backed up and gave me enough room," Kilian recalls. "(Jermaine Landrum) caught the ball for about six yards and made the guy miss, which is typical of Jermaine. Then he made two other guys miss and then you realize he's going to score a touchdown."

"Jermaine Landrum's play at the end of the game is the signature play of the entire season," Tulsa World sports writer Tramel adds. "If you can have one image stamped in your head of the kind of magical season it was, that would be it. If you look at that guy, he looked like a big starfish. All of his limbs were extended and the only part of his body that was in bounds was his wrist and the football. It was an amazing individual play after he caught the ball."

Tulsa entered its final home game of the season needing one more victory to secure its first winning season since 1991. The opponent was Louisiana Tech, an underachieving, but always dangerous team that had destroyed TU 53-9 a year earlier. TU was again facing a flashy NFL-caliber quarterback in the form of Luke McNown.

But thanks to TU's stingy pass defense and the combined offensive performance of Richardson and Kilian, Tech never really had much of an opportunity to win the game. Richardson led the charge on Senior Day with 21 carries for 154 yards and two touchdowns. His 80-yard scoring jaunt in the third quarter electrified Skelly Stadium.

The Golden Hurricane headed into its final game with a legitimate chance to go to a bowl game. At San Jose State, things looked good early on for TU as Kilian moved the ball effectively. Through the third drive, he had completed six of eight passes for 47 yards and a touchdown to give TU a 7-6 lead. But something happened during that drive that would greatly impact the rest of the game.

"We got down around the goal line and typical of us, we ran an option," Kilian recalls. "I kept it and tried to get in. There wasn't anything unusual about the hit, but when we landed, [the defender] landed on top of me and my shoulder was driven into the ground. I really didn't feel a pop and I just thought it was another stinger. I couldn't move my arm much but I thought I'd be okay. I was hoping they would take me and I could just pitch it and not get hit. They take the tailback and the linebacker peels off and I have to hit him again with the same shoulder. The pain that shot threw my body told me that it was broken. We called time out and as we were going over to the sidelines, I slipped my hand underneath my shoulder pads and I pushed on that collarbone and I felt where [the bones] were bouncing past each other."

Kilian told the coaches to get Paul Smith ready then went back into the game where he threw a short touchdown pass to Caleb Blankenship. Smith, a true freshman, had played sparingly thus far in the season and it took him several plays to get on track. By then, San Jose State had upped its lead to 19-7. TU answered back with an 80-yard touchdown drive. Tulsa's defense had a major relapse that allowed the Spartans to take the ball 75 yards in just 35 seconds.

TU faced another 12-point deficit to start the second half. A much more confident Smith led TU on three unanswered touchdowns drives including a four-yard score of his own and a pair of trips to the end zone for Richardson. The Spartans fought back late in the game with a quick four-play, 68-yard scoring drive that brought them within two points of TU.

After TU's following drive stalled, San Jose State took over at its own 10-yard line and needed only a field goal to reclaim the lead. The Spartans moved the ball to midfield where they faced a fourth and one situation. But much like the Rice game, TU's defense came up with a season-saving stop led by junior college transfer Michael LeDet.

TU would have to wait to learn of its bowl fate, but there was no doubt that the Hurricane's 8-4 record coupled with its tie for second place in the conference would earn the team one more game.

Michael LeDet and Shannon Carter team up to make a tackle on SMU's quarterback. In Carter's first season, he finished fifth among all TU defenders with 76 tackles. He also collected three interceptions, two pass breakups and he forced two fumbles. Carter was a true freshman in 2003 after spending the past six years playing minor league baseball. (The University of Tulsa.)

Caleb Blankenship gains yardage after catching a pass against UTEP. The junior tight end finished the season with 33 receptions for 387 yards and two touchdowns. Blankenship also scored a rushing touchdown in the UTEP victory. He was an All-WAC honorable mention. Both his father Bill and brother Josh previously played football at TU (The University of Tulsa.)

Brandon Lohr pursues a UTEP player. Lohr finished the season with 45 total tackles including 4.5 for minus 21 yards and one sack for minus 10 yards. (The University of Tulsa.)

Romby Bryant makes a leaping grab against UTEP on a pass that quarterback James Kilian was trying to throw away. He finished the season second among all TU receivers with 47 receptions and led the team in receiving yards with 748. Bryant's 80-yard touchdown reception against Boise State was the seventh longest in school history. He was a Second Team All-WAC selection. (The University of Tulsa.)

Against Rice, Jermaine Landrum caught three passes for 43 yards. More importantly, he caught a six-yard pass from Kilian and turned it into a spectacular 31-yard game-clinching touchdown. He finished the season with 28 catches for 277 yards and 33 carries for 222 yards. Landrum also added 296 punt return yards and scored three touchdowns. (The University of Tulsa.)

Eric Richardson stood tall in Tulsa's 48-18 victory against Louisiana Tech. He rushed 21 times for 154 yards and two touchdowns including an 80-yard scoring play. By season's end, Richardson had gained 2,645 yards during his four-year career surpassing Howard Waugh for second on TU's all-time rushing chart. He was a 2003 All-WAC honorable mention. (The University of Tulsa.)

Oliver Fletcher made an immediate impact as a junior college transfer. He tallied 47 total tackles, five pass breakups and a team leading four interceptions. (The University of Tulsa.)

With second place in the Western Athletic Conference and a bowl bid on the line, true freshman quarterback Paul Smith was forced into action on the road against San Jose State when James Kilian broke his collarbone in the first quarter. Smith completed 10 of 17 passes for 166 yards and he scored the first rushing touchdown of his young career. (The University of Tulsa.)

TEN

Bowl Bound

Heading into the Humanitarian Bowl, no one really knew what to expect. The Golden Hurricane had shocked and amazed people all season long, so anything seemed to be possible. James Kilian's broken collarbone was healing nicely and the January 3 date gave him even more time to recover and prepare.

For most TU fans, Georgia Tech was a mystery. Their 6-6 record seemed mediocre at first glance, but a closer look revealed some impressive outings including victories against Auburn, North Carolina State and Maryland plus a near upset on the road against Florida State (14-13). After studying the opponent much closer, Jimmie Tramel could see that Tulsa would have to contend with a massive defensive line, a speedy defensive secondary and the unpredictable offensive tandem of quarterback Reggie Ball and tailback P.J. Daniels.

"Georgia Tech was bigger, stronger, faster," Tramel says. "For Tulsa to really have a chance, Georgia Tech would need to have a mindset that they really didn't want to be in Boise. Georgia Tech did play like they wanted to be there and the fans never really had a chance to get in Tulsa's corner. Those intangible things that Tulsa needed never happened."

Tulsa had two major problems with the Yellow Jackets. The first was its inability to stop the running game. TU had improved greatly from the 2002 season when they gave up 256 rushing yards per game. In 2003, the Golden Hurricane lowered that number to 183 yards per game. But that improvement wasn't enough to stop Daniels who had a career day with 307 yards and four touchdowns. Georgia Tech's passing offense was non-existent and for good reason as they tallied 371 of its 390 total yards on the ground.

"One of the few weaknesses that was not corrected during the season was Tulsa's run defense," Tramel says. "It was still very thin. Tulsa was so great at pass defense and the WAC is such a pass-happy conference. But once you play teams that can power run, that's still very much an Achilles heel for Tulsa as we saw in the bowl game."

TU's other struggle came from an uncharacteristic turnover problem. Throughout the season, Tulsa was one of the nation's best at handling the football. In particular, TU had only lost five fumbles all year long. The Golden Hurricane's pass protection was also much improved as they allowed just 16 quarterback sacks. Against Georgia Tech, however, TU gave up seven sacks and consequently, fumbled the ball six times, once more than the total for the other 12 games.

"Georgia Tech had better athletes on defense that could pressure the passer and they did get to James Killian a lot," Tramel says. "Tulsa didn't get its down field passing game going at all."

Kilian is quick to give Georgia Tech credit, but also says that he and his teammates should take the greater responsibility for saving its worst performance for last.

"Georgia Tech is a good football team," Kilian says. "I don't think they were that much better than us. It was disappointing for me and I think as an offense. We had too many turnovers. The offensive line didn't feel good about their protection. It just wasn't our day. I don't think it was because we just wanted to be there. I don't think that's the reason why we came out flat. I don't know why we came out flat because it was a huge game for us. To not came out and compete and play as well as we'd been playing to get us to that point was disappointing for us."

Georgia Tech went on to win the game 52-10 and some media representatives and college football fans publicly questioned whether or not TU actually deserved to be there in the first place. Coach Kragthorpe was quick to defend both his team's post-season participation and the achievements of the entire year. Even with their coach's encouragement, the flight back to Tulsa was tough for the entire team. Privately, some of the players expressed their concerns that the amazing turnaround might be diminished by the lopsided bowl defeat. Kilian was certainly disappointed, but had no intentions of letting one game take away from a season full of incredible memories.

"I'm a guy that gets over it," Kilian says. "Whether it's a win, I'm down pretty quick to get ready for the next game and a loss, I'm up shortly after. Some guys were upset and said they weren't going to wear their bowl rings. But I'm wearing mine just to remember what it took to get us here. Just for us to get to this point is an accomplishment in itself. Nobody expected us to finish second in the WAC when we were picked last. We have nothing to be ashamed about."

"The silver lining is that an incredible monkey was off Tulsa's back," Tramel adds. "Whether you win or lose the ball game, it was of great significance to end a string of 11 consecutive losing seasons. The wicked witch is dead. So let's see what happens from here."

TU's 8-5 record represented the most dramatic improvement for all NCAA Division 1-A schools from 2002. Not only did the turnaround show up in wins and losses, but the Golden Hurricane numerous post-season honors for its effort. Kragthorpe was named a finalist for the Bear Bryant Coach of the Year Award and a semifinalist for the Eddie Robinson Coach of the Year Award. The Football Writer's of America Association (FWAA) named him First-Year Coach of the Year. Kragthorpe was named WAC Coach of the Year, he was a finalist for the FWAA Coach of the Year Award, and finished in a third-place tie with Oklahoma's Bob Stoops for the Associated Press honors.

Nick Bunting led the way for individual player awards with his placement on the FWAA's Freshman All-America Team. He was also named WAC Freshman of the Year and a conference First-Team selection. Tight End Garrett Mills was named a First-Team performer along with offensive lineman Austin Chadwick. WAC Second-Team selections included wide receiver Romby Bryant, quarterback James Kilian, linebacker Michael LeDet and defensive backs Jermaine Hope and Kedrick Alexander.

Tailback Eric Richardson finished his career by surpassing TU Hall of Fame inductee Howard Waugh as the school's second all-time leading rusher. He became just the ninth player at Tulsa to rush for over 2,000 yards with a final tally of 2,645.

The Golden Hurricane ended the 2003 season looking towards a bright future. With a move to Conference USA on the horizon (Tulsa officially joins in 2005), The University of Tulsa readies itself for another successful run at gridiron glory. If the past truly does repeat itself, TU fans might want to expect the unexpected.

Kedrick Alexander makes one of his nine tackles in the Humanitarian Bowl with this play on Georgia Tech tailback P.J. Daniels. It was one of the few times Daniels was stopped that day as he rushed for 307 yards and four touchdowns. Alexander was named Second Team All-WAC. He was TU's leading tackler with 121 total tackles and tied for the most interceptions with three. (The University of Tulsa.)

Senior Cort Moffitt boots one of his seven punts against Georgia Tech. He averaged 45 yards per punt and was named TU's Humanitarian Bowl MVP. Moffitt finished the season with a 43.7 average including a 72-yard punt against Boise State. (The University of Tulsa.)

Garrett Mills scores TU's only touchdown against Georgia Tech on a pass from Paul Smith. Mills had three receptions for 27 yards on the day. For the season, Mills led TU receivers with 53 receptions and 10 touchdowns. He was second in receiving yards with 456. He was named First Team All-WAC. (The University of Tulsa.)

The 2003 team was the most improved team of the year, having gone from 1-11 in 2002 to an 8-5 season and an appearance in the Humanitarian Bowl. Picked to finish last in the WAC, Tulsa went 6-2 and tied Fresno State for second place. Tulsa garnered three First Team All-WAC selections, five Second Team All-WAC selections and four All-WAC honorable mentions. (The University of Tulsa.)

On November 4, 2003, athletic director Judy MacLeod was all smiles as she and university president Dr. Bob Lawless announced that in 2005, The University of Tulsa would be leaving the Western Athletic Conference for Conference USA. The change will mark the fifth conference affiliation for TU since it joined the Oklahoma Collegiate Conference in 1914. (The University of Tulsa.)